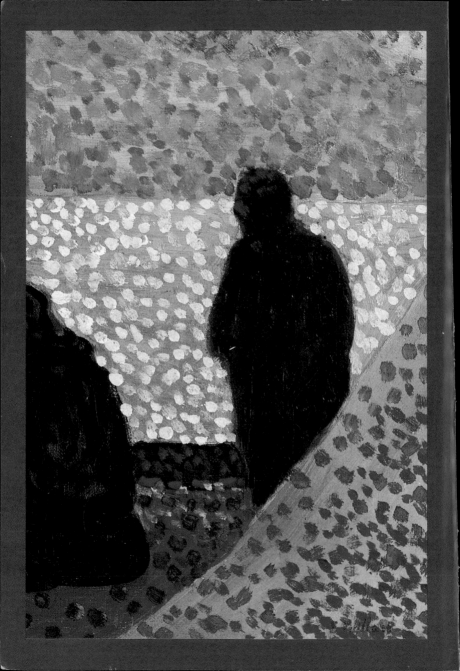

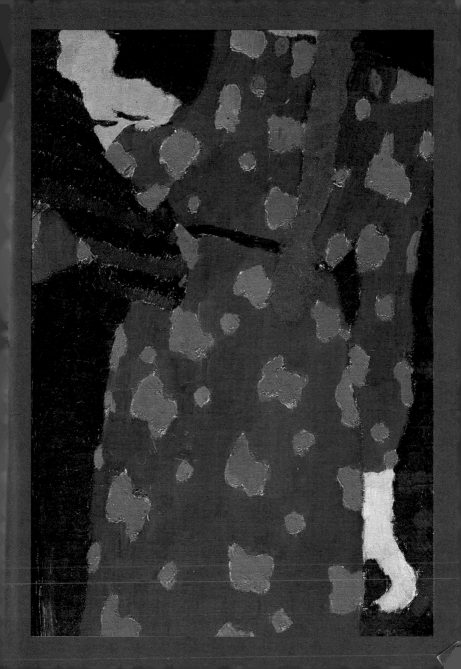

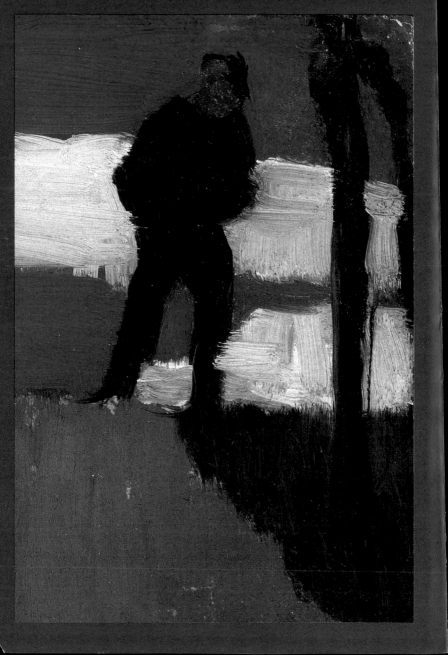

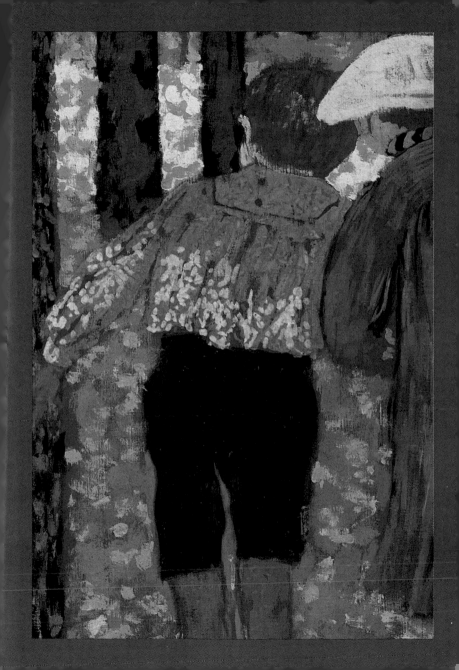

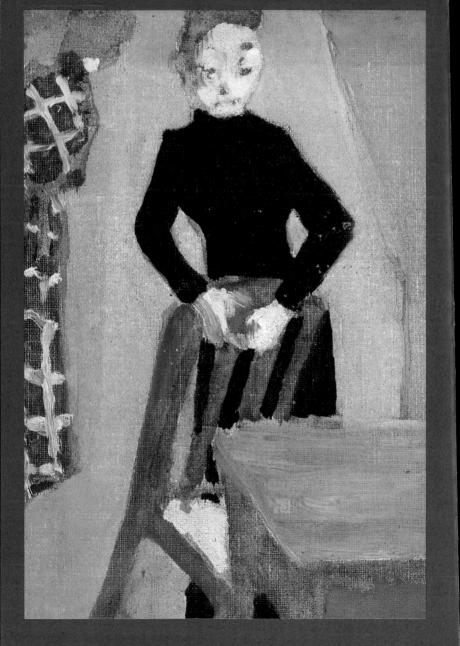

CONTENTS

VUILLARD
POST-IMPRESSIONIST MASTER

Guy Cogeval

DISCOVERIES®
HARRY N. ABRAMS, INC., PUBLISHERS

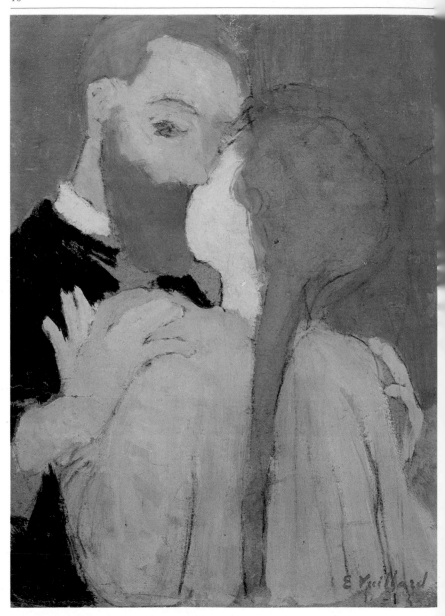

Edouard Vuillard's creative life was entirely lacking in flamboyance. At no point did he do anything to attract trivial gossip, nor did he indulge in a flashy parade of heroism with the obligatory series of scandalous challenges to convention. The only episodes that stand out in his life were a number of journeys, all within Europe, a brief period of military service in 1914, and the admission to the Institut de France which crowned the end of his career.

CHAPTER 1
WHAT IT MEANS TO BE A NABI

The Kiss (c. 1891) is no doubt the only work in which Vuillard shows himself in the act of embracing another person, here probably a young seamstress from his mother's workshop. A photograph of the artist from around 1899 shows a man who combines modesty with a deeply questioning nature.

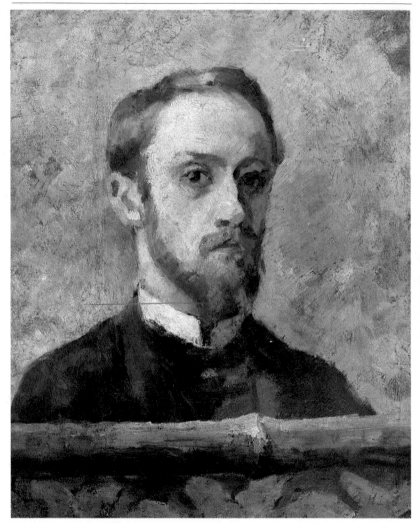

The accounts of his contemporaries stress the propriety and extreme reserve of Vuillard's appearance. Youthful self-portraits already show him with a red beard which elongates his face and accentuates his natural seriousness. As Jan Verkade, the most religious of the Nabi painters, recalled, Vuillard was "French to

Self-Portrait in a Mirror (1887–88). Already a subtle artist before he met the Nabis, the young Vuillard showed himself as Antonello's *Salvator Mundi.*

the core, and even of the type of a St. Francis de Sales whom he strikingly resembled...a fine man, with a delicate consideration for others, which he never displayed immoderately, for fear of seeming insincere."

Vuillard is believed to have said, "You achieve success either by one glorious feat, or by seniority." In his case the two paths were complementary; in him the child, with a fresh, selective outlook on life, coexisted

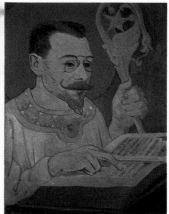

with an old man viewing the world through the eyes of memory. As a result, it is very difficult to separate his life into dates and periods. Certainly his sensibility and above all his style did evolve, but the development was in no way linear. Vuillard was neither an extrovert revolutionary nor a Sunday painter, and the path that he took within the heart of the modern tradition was a highly unusual one.

To say that a thing is beautiful is simply an act of faith, not a measurement on some kind of scale (Vuillard, Journal, 2 April 1891)

Nabi. This once mysterious and now almost over-used word is said to have been suggested to Maurice Denis by the poet Henri Cazalis. *Nebîîm* in Hebrew means "prophets," or "visionaries." At the turn of the 1890s, the word was quite familiar, owing to the popularity at the time of occult religions and theosophy. "It gave us a name which, in the eyes of the [art] studios, made us into initiates, a sort of mystical secret society, and it proclaimed that to be in a state of prophetic transport was normal for us," Maurice Denis would recall in 1934.

The rejection both of the official realism taught in the studios of Bouguereau and Cormon (which they attended at one time), and of

A love of the esoteric, the study of Semitic languages, and references to Wagner, Swedenborg, Schopenhauer, and Schuré's *The Great Initiates*, were all unifying factors for the Nabis. At the beginning they were tempted by neo-Platonic Symbolism, according to which "natural objects are the signs of ideas, and the visible is the manifestation of the invisible" (Maurice Denis). Left, a painting by Paul Sérusier shows Paul Ranson, the most theosophically inclined of the group, in Nabi costume. Below, Joséphin Péladan, known as the Sâr, in his Chaldean costume, painted by Alexandre Séon. Péladan, an art critic and author of *The Supreme Vice*, founded the Symbolist and occultist salon of the Rosicrucians in 1892.

Impressionist hedonism (about which they knew very little before 1895), drove a generation of young painters to attempt between 1888 and 1890 to seek out certain truths that would direct them toward a radical revival of painting. What was miraculous about their adventure was that their experiments were carried out in a completely empirical way.

Maurice Denis recalled that their initial association began with Paul Sérusier's presentation of his famous *Le Bois d'amour*, painted at Pont-Aven in 1888 under the direction of Gauguin, and soon renamed "*The Talisman*." This small picture on a cigar box cover became the manifesto of the synthetism to which the young painters aspired. According to Denis, the little landscape, which was "formless, because it had been conceived synthetically, in violet, vermilion, Veronese green and other pure colors, just as they come out of the tube," showed them the way to a new freedom, to a regenerated art which was open to the imagination. Art could now be a subjective deformation of nature instead of a mere copy of it.

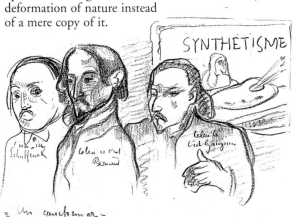

*L*e Bois d'amour (above), by Paul Sérusier, was to become the Nabis' "talisman." Below, a caricature of the Pont-Aven synthetist group by Emile Bernard, who claimed to be the creator of synthetism. Gauguin soon distanced himself from Bernard's rigid dogma, stating that *sintaise* [a deliberate misspelling of 'synthèse'] rhymes with *foutaise* ("bullshit").

"For Vuillard, the crisis brought about by Gauguin's ideas was of short duration; he owes him the solidity of the system of marks upon which he bases the intense and delicate charm of his compositions."
Maurice Denis

The group of young artists, which included Pierre Bonnard, Henri Ibels, Sérusier, and Denis, claimed to draw its inspiration from Gauguin, Puvis de Chavannes, and Primitivism. They spent long evenings endlessly discussing Wagner, philosophy, eastern religions, and contemporary theater at the "Dîner de l'os à moelle" ("Marrowbone Dinner") in the Passage Brady, or better still at Ranson's studio which was renamed "The Temple" for their ritual gatherings.

The good child

That Vuillard should join a group of revolutionary young painters was not entirely predictable. Born at Cuiseaux near Lyon on 11 November 1868, into a lower-

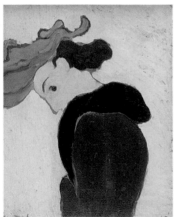

middle-class family, he was fifteen when his father died. His mother, who owned a corset-making shop in Paris, took charge of the young painter's education and won the admiration of his friends by the compassionate and steadfast way in which she encouraged his artistic leanings. It was no doubt

Two "synthetic" works by Vuillard: *Woman in a Green Hat*, and the portrait of his fellow Nabi and future brother-in-law, Ker-Xavier Roussel. The forms are simplified to the point of caricature, shadows are banished, and the areas of color are outlined like cloisonné enamel work.

the enlightened education he received at the Lycée Condorcet, where he went from his first school, run by the Marist Brothers, that gave the young Vuillard his opening on to the world. He also made lifelong friends there, such as Ker-Xavier Roussel and Aurélien Lugné-Poe.

When he left the lycée he had a brief spell at Diogène Maillart's studio, then a longer period when, not without pride, he attended the studios of Bouguereau, Robert-Fleury, and Gérôme. His real artistic training took place elsewhere, however, mainly during the visits he regularly made from 1885 to 1888 to the Louvre. Here he drew inspiration both from Dutch 17th-century painting and from the 18th-century French School, as can be seen from the numerous sketches in his journal of the time, and from a few paintings

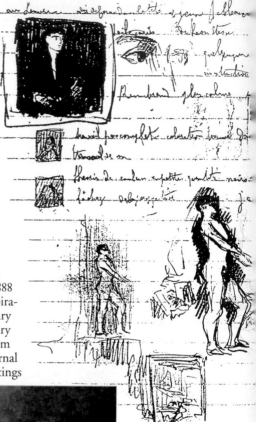

Vuillard's academic apprenticeship was more complete than that of the other Nabis. One of his early works, *Still Life with Salad* (1887–88), painted with small brushstrokes of modulated color, appears to be a tribute to the silent art of Chardin.

inspired by the old masters. Although he admired Holbein and Veronese, his very earliest paintings, such as *The Wild Rabbit* and *Still Life with Salad,* show that he was more strongly influenced by Vermeer, Chardin, and Corot—"Corot, an accent in some hazy thing, in a perfect harmony of a number of grays, a sound…" (Journal, 31 August 1890). Clearly, when he encountered the new group that had formed, consisting of Pierre Bonnard, Maurice Denis, Paul Sérusier, and other friends from the Lycée Condorcet, he was torn away from his natural milieu.

In 1888 Vuillard started to keep a journal in which he recorded his walks along the banks of the Seine (which inspired *The Stevedores,* (pages 24–5), his nocturnal wanderings with his friends, as well as his evolving thoughts about art. "We perceive nature through the senses, which give us images of forms and of colors, or sounds, etc. A form, a color, exists only in relation to another. Form on its own does not exist." (Journal, 20 November 1888). His true conversion perhaps took place in the summer of 1890, when Paul Ranson, the most esoteric of the Nabis, lent him his studio.

The Journal that Vuillard kept in his youth (center) was a very odd collage of notes—mostly aesthetic and philosophical reflections scribbled at random—and images, anatomical sketches, details of paintings in the Louvre, street scenes…

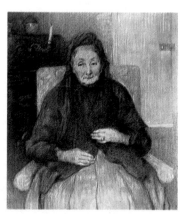

Above, *Portrait of Grandmother Michaux,* who lived with the Vuillard family until her death (1893), and was always dressed in mourning.

The profane Zouave

Most commentators on the work of the "Nabi Zouave" (referring to his clipped, military-style beard) have been

particularly careful to show how atypical his character was compared with the other members, who were more attracted by metaphysics, idealism, and the search for strict compositional rules, and who relied more on the Symbolist movement still dominant at the time. Vuillard, along with Bonnard, was considered the most secular of the Nabis.

From his Lycée Condorcet days until his death, Vuillard was linked to Bonnard by fraternal bonds.

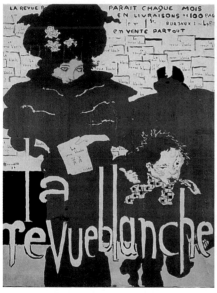

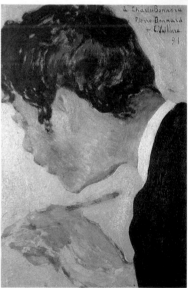

Early on they shared the same studio, saw each other every day, and together braved the adventures of *La Revue blanche*, the Théâtre de l'Œuvre and Théâtre des Pantins (Puppet Theater). We need only look at the iconography of their respective paintings to see the deep affinities between them: bourgeois interiors, the feeling of time passing, the capturing of the moment. From the 1890s on critics linked their names automatically, and as Thadée Natanson, the editor of *La Revue blanche* remarked, "they are the only people who don't see any similarity at all between their

In 1892 the Nabis began to work for *La Revue blanche*, a magazine founded two years earlier by Thadée Natanson. This avant-garde publication devoted a great deal of space to the current aesthetic debate (left, Bonnard's poster for *La Revue blanche*, 1894).

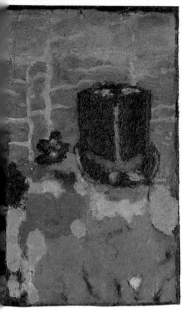

panels...What they do think is similar is the sort of painting they yearn for."

"Nothing is important save the spiritual state that enables one to subjectify one's thought to a sensation."

Although it may seem that Vuillard's style was based from the outset on subjects drawn from everyday life, we must not forget Denis's influence. Denis was the "Nabi aux belles icônes" (Nabi of beautiful icons), and for him art could have no other subject than the state of the soul or the idea that it expressed through the formal language of painting.

If the pictorial object is meant to be the sensory equivalent of an impression, or sensation, then Vuillard is in line, albeit very reservedly, with this Symbolist trend. As expressed in an early journal entry, "Nothing is important save the spiritual state that enables one to subjectify one's thought to a sensation, [and] to think only of the sensation, all the while searching to express it. At the moment my mind is numb, not long ago it was so active." (6 September 1890)

Later he added, with a certain bitterness: "It is therefore essential to have a method of painting, in order to produce, without *knowing* in advance what will be the result. Let us be clear, I must imagine, see, the lines and the colors I apply, and do nothing haphazardly, that's perfectly true. I must think about all my combinations. But even to attempt this work, I must have a methodology I can trust. I have always worked too haphazardly, and because of that these are certainly

"The two young painters are always in a hurry to show each other what they are doing, and Vuillard, who is the more enthusiastic of the two, would happily agree never to have any other judge.... They talk about museums and the canvases of their elders, which can be seen at the Durand-Ruel gallery or at Goupil's, or after at Père Tanguy's. They confide in each other about their projects... Vuillard is often at Bonnard's home, and he is one of the few people with whom Marthe [Bonnard's future wife] is willing to be sociable.... I wouldn't say that Vuillard is the more openly affectionate of the two, as much as the only one who is. However he has such an understanding nature, and above all such great delicacy that he knows how much Bonnard hates and even more fears any show of affection....I should add that, as close as they have been, they have never called each other 'tu'."

Thadée Natanson

Vuillard gave Bonnard's brother his portrait of *Bonnard in Profile* (center). Bonnard's *Portrait of Vuillard* 1892, remained in Bonnard's collection.

not works in the pure sense, this work does not truly originate from me; if the drawings at the Conservatoire, the programs for the T[héâtre] L[ibre] and the drawings for the pantomime show have any personality at all it's in spite of me, and I'm doing everything I can to kill it off, although I don't understand why, because there is nothing absolute in our theories, they are bestowed by grace. But why do I feel at such a loss every time I start a new series: it's because I don't have a firmly settled method that would free me from the vulgar concern to be original. Only a properly established method can give me peace of mind and of course enable me to deceive myself; Sérusier is right to say that we should not concern ourselves with subjective expression in our painting. That's the business of the contemplator." (24 October 1890)

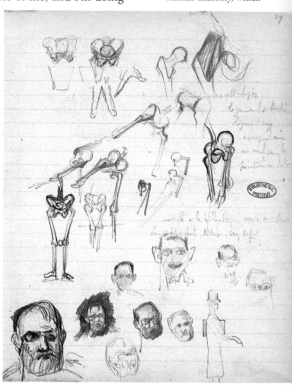

Students at the Ecole des Beaux-Arts not only did sketches from live models, they were required to know human anatomy, which sometimes meant sketching at the Ecole de Médecine (Medical School). Vuillard's Journal includes one very odd-looking page on which caricatures and fragments of handwriting are made to fit a rather astonishing image of dancing skeletons.

"The word harmony means nothing but science, knowledge of relationships and colors." (Vuillard, Journal, 30 October 1890)

Denis himself does not say a great deal about Vuillard in his early journal; it was not until they were sixty that their relationship grew stronger. Even so, Denis took a very real interest in Vuillard's work during the Nabi period: "These little bedrooms are extraordinarily decorated with little drawings and paintings; he has a

very rare talent. Vuillard is worth more than any of us."
And again: "I envy Vuillard's good fortune; he paints
nothing but what he wants to paint, and still profits
from it." Moreover, Vuillard, the painter of seamstresses'
workshops and public parks, comes close to Denis's
aesthetic principles when he claims that the analogy is
"a symbol…which cannot be expressed merely by
listing the objects that determined it." (Journal,
6 December 1890)

The little dab and the flat patch

Like all young painters in
the late 1890s, Vuillard
looked closely at
Seurat's painting.
It can even be
said that in the
course of 1890–91
he went through
a real neo-
Impressionist

A nother page, purely
graphic this time,
shows hieratic female
figures, stylized in the
manner of Maurice
Denis—perhaps figures
from tragedy, in partic-
ular the grief-stricken
woman—alternating with
grotesque facial expres-
sions, one of which, the
smiling African Zouave,
Vuillard would have
known from the adver-
tisement for Banania
cocoa. The page
clearly shows the
complexity of the
young painter's
sources of
inspiration.

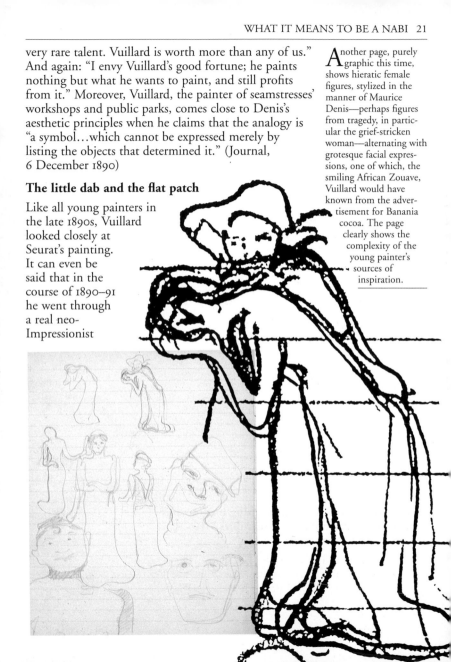

digression, illustrated by works such as *Grandmother with a Soup Tureen*, where the image of the artist's grandmother is obliterated in an explosive spray of color, and *The Stevedores*, in which there is no attempt to adhere to a realist model.

In comparison with contemporary works by Seurat's close neo-Impressionist colleagues, Paul Signac or Henri Cross, Vuillard's paintings, in which masses of superimposed colors dissolve the contours that objects have in reality, seem headed toward 20th-century painting. It may well seem astonishing that this timid, cautious, self-effacing artist should have displayed such self-assurance in his quick little sketches (which he called *petites salissures* or 'dirty little marks'), and plunged with such delight into the unknown territory of a totally experimental, unfinished type of painting which was radically freed from the subject.

In the *Schematic Portrait* of his sister (above left), as in *Grandmother with a Soup Tureen* (center), Vuillard used pointillism not as a science but as a decorative language, from which he took the idea for flat patches of color.

The *Octagonal Self-portrait* is one of the most accomplished demonstrations of Gauguin's theory of pictorial synthetism; the yellow hair, pink face, and orange beard are unmodulated patches of color which are brutally juxtaposed, and accented by a gray stroke over the face to indicate shadow.

Despite his interest in Seurat, Vuillard's painting during this very short period was primarily influenced by the principles of using flat patches of color and interlocking forms, which were in a sense a very personal reinterpretation of the models provided by Gauguin during his Pont-Aven period. For those who are most resistant to the bourgeois atmosphere, scent of chamomile, and gloomy rigor of the linen-

Vuillard's self-assertion appears to triumph in this self-portrait, in which the sacred quality of a figure in an octagon (a fusion of the circle and the square, associated with baptism and the rebirth of the soul) is further accentuated by the shower of tiny smudges which form a halo around the artist's face. Like a modern *condottiere*, he turns slowly to stare at the spectator with his two dark eyes and an enigmatic expression that is both questioning and challenging. The octagon and the stippled background serve to unify the different and very separate areas of the face.

cupboard that emanate from so many of Vuillard's paintings, this period, 1890–92, is the most immediately, almost brutally, dazzling, and the clearest pointer toward the transgressive abstractions of modern art.

Paintings from these years such as *Lilacs* and *The Dressmakers* can generally be judged only by using the reference system for Fauvist and abstract art. It is hard to believe that a young man who a few months

"The purer the elements used, the purer the work. In painting there are two means of expression, form and color; the purer the colors, the purer the beauty of the work;... what is remarkable in the museums and in the history of painting [is that] the more mystical the paintings are, the more vivid their colors are (reds, blues, yellows), and the more materialistic the painters are the darker the colors they use (clays, ochers, tar-blacks)."

Journal,
31 August 1890

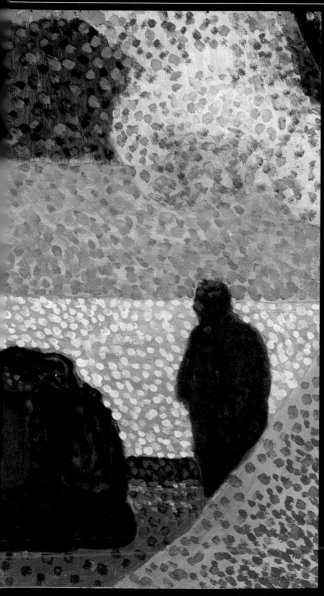

"Conceive of a picture really as a series of harmonies, moving away finally from the naturalistic idea," wrote Vuillard in his Journal on 31 August 1890, as if in response to Maurice Denis's article, "Definition of Neo-traditionalism", which had appeared in *Art et Critique* a week earlier: "Remember that a painting—before being a battle horse, a nude woman, or some anecdote—is essentially a flat surface covered with colors assembled in a certain order. I am trying to find a *painter's* definition of that simple word 'nature'... Probably: the sum total of optical sensations."

The Stevedores shows the appeal that Seurat's scientific "pointillist" system had for Vuillard, and the importance for all the young painters of demonstrating Chevreul's theories concerning light and the chromatic spectrum. Even so, the structuring of the space in parallel bands, the abstract mass formed by the sacks sitting on the quay, the pile of yellow sand (the men are emptying a tipcart on the banks of the Seine) make this one of the most advanced works of its time.

earlier had been strongly influenced by Chardin could have conceived of a painting as violent as *Lilacs*. Here he completely rejected contours and brought into play

A rt is the sanctification of nature,…the universal triumph of the imagination of aesthetes over the stupidity of attempts to imitate, the triumph of the emotion of Beauty over the lies of Naturalism." This statement by Maurice Denis was anticipated by *The Lilacs* (bottom), *The Bois de Boulogne* (left) and *Madame Vuillard in Red.*

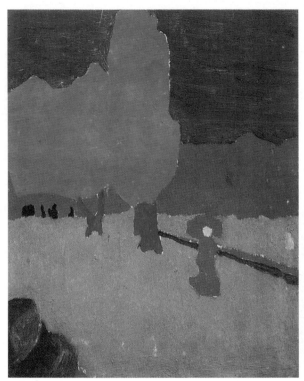

a collage of brilliant colors which marked the advent of pure chromatic discord, at the very moment when Maurice Denis was painting his *Patches of Sun on the Terrace.*

In the same way, works such as *Madame Vuillard in Red* and *Little Girls Walking* introduce a chromatic aggressiveness for which it would be difficult to find an equivalent in the same period. The second of these paintings is a masterful demonstration of this first Vuillardian "system"—a refusal to yield to the anecdotal, hidden physiognomies, with decorative patterns

juxtaposed with one another (brown stripes against the spotted blue dress). Finally one sees also the artist's predilection for awkward, unstable body postures which create an intentional effect of imbalance and decentering.

With his *Little Girls Walking*, Vuillard applied the principles of synthetism to a format appropriate for monumental painting.

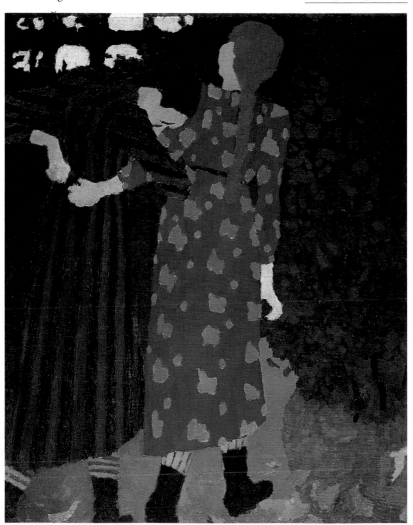

The Japanese influence

Between 1890 and 1892, Vuillard assimilated
the main themes of Japanese art and used them
in his work. Following the example of Denis
and Bonnard, he collected Japanese prints,
especially after the great exhibition of Japanese
art at the Ecole
des Beaux-Arts in
1890. Among
others, he owned
Hokusai's *Manga.*
Vuillard's *japonisme*
results in an over-
determination of
shapes, increasing
the expressiveness
of forms. His desire
to create a clear,
linear style that
rejected illusions
of depth and of
objects "turning"
in space was
confirmed by what
Far-Eastern art
suggested to him.
 Nabi painting
was to be a final
phase in the assimi-
lation of Japanese
art, following the
generation of
Manet, Monet,
and Whistler, then
that of Seurat and

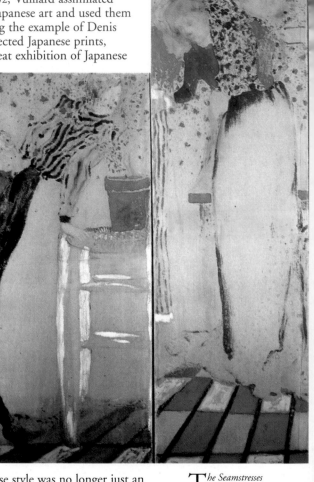

Gauguin. The Japanese style was no longer just an
opportunity to borrow an iconography; it triumphed as
a codified reconstruction of the visible world, showing
figures with no individuality, contrasting rhythms,
vertically superimposed planes, vegetation dictated by
the demands of decorative principles, and flattened
figures gliding over empty surfaces.

*The Seamstresses
Folding Screen*,
painted for Paul
Desmarais, a cousin of
the Natanson brothers,
resembles a medieval
altarpiece, inspired also
by Japanese art.

The Nabis also adapted their painting to Far-Eastern formats, such as the fan, which enabled them to distort the image into a half circle (*Fan of the Bethrothed* by Denis, and *Women and*

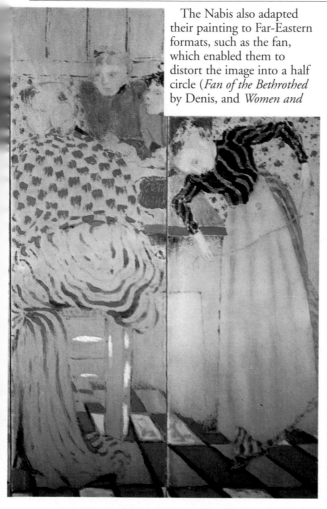

Each female figure is fitted into one panel of the screen, which takes the traditional form of the *kakemono* (panels which are usually three times as high as they are wide), so that the artist is forced to elongate the figures. The very dense colorings of the ground (a tiled floor worthy of Paolo Uccello), contrast subtly with the almost evanescent presence of the female figures, whose contorted postures no doubt echo those of the courtesans of Hiroshige or Kuniyoshi, but are also reminiscent of many Italian Mannerist works by Pontormo and Parmigianino. Most important, the use of brushstrokes to portray the figures is very sparing, so that over a large part of the painting's surface the canvas remains untouched, as if kept in reserve. Here Vuillard is empirically employing methods of painting that would be systematized about ten years later by Braque and Matisse, in particular around 1905–06 when they painted at Collioure in southern France.

Flowers by Bonnard, both from 1891). Vertical narrow panels, inspired by the Japanese *kakemono*, were Bonnard's special domain; *The Peignoir* (1892) shows the feminine form, elegant, contorted, and imprisoned in tight coils of hair. Sometimes panels were hinged together to form folding screens, in vogue

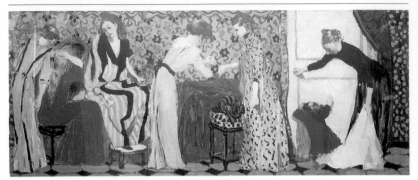

at this time; Bonnard's *Women in the Garden* was
followed shortly after by Vuillard's *The Seamstresses*—
both delicate, emblematic works touched by the
Symbolist aesthetic.

It was partly Vuillard's familiarity
with Japanese art that led to the
flat-planes of color seen in the early
works, and also to his interest in
representing parallel points of view.
The *Desmarais Panels*, for instance,
his first decorative commission
received in 1892, show alternate
scenes of the ground viewed both
as receding into space and rising
upward, with human figures
who dominate the picture plane.
They also present a succession
of scenes, some of which
(*The Dressmakers' Shop I and II*)
are dominated by a profusion of
detail and syncopated rhythms.
Others (*Gardening* and the
The Shuttlecock Game) are more
restrained, with neutral surfaces
and sandy or pale green colors.
These six panels represent the
extreme to which Vuillard
experimented with a type of
painting in which his traditional
subjects (seamstresses, children's

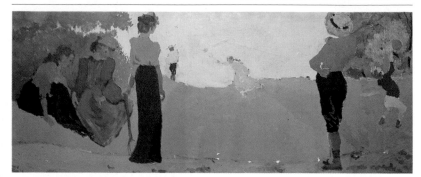

games, garden scenes) were completely absorbed by a variety of visual devices which determine the way it is perceived.

One painting which best embodies the combined influences of synthetism, Symbolist thinking, and the

decorative arts of Japan, is *In Bed* (1891). Here the palette is minimal; a large, flat patch of uniform color is delimited by lines which run through the whole work. The outlines form parallel bands and arabesques which impart almost musical rhythms to the entirely sealed-off, hothouse atmosphere. This mysterious representation of sleep in broad daylight is based on strictly defined zones so that the cerebral, as opposed to the atmospheric and tactile, impression prevails.

The six panels commissioned by Paul Desmarais were the first decorative ensemble that Vuillard produced (1892). The panels were installed in two vertical groups of three in a grand salon in Rue de Lisbonne. Here, *The Dressmakers' Shop I* and *The Shuttlecock Game* attest to the artist's subtlety—in his use of sumptous materials and arrangement of undulating figures which give to the whole group a kind of choreographic movement.

Vuillard turns the very simple subject of a child asleep in bed into a mysterious, Symbolist object. The flat patches of white are among the most radical in his oeuvre.

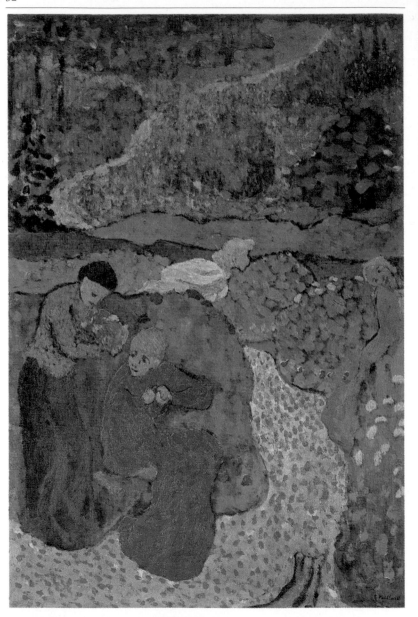

"The dramatic poet is obliged to bring down into real life, into everyday life, the idea that he has of the unknown," stated Maurice Maeterlinck in the preface to his *Théâtre* (1901). Vuillard achieved this by painting his pictures as strange, complex pieces of stage scenery.

CHAPTER 2
JUST LIKE THE THEATER

The recently rediscovered *Women in the Garden* is a paraphrase of P. N. Roinard's *Cantique des Cantiques* (*Song of Songs*), produced in 1891 by Paul Fort at the Théâtre d'Art, with highly Symbolist sets by Vuillard. Right, a program for Antoine's Théâtre Libre production of *Monsieur Bute* (1890).

Edouard Vuillard's involvement with Symbolist drama was inextricably linked to his friendship with Aurélien Lugné-Poe, who was one of the great reformers of the theater in the 20th century, along with Antoine, and the Russians Stanislavski and Meyerhold. Although today it may seem quite normal for a painter to take part in an experiment in stage scenery, this was by no means the case in the 19th century. There was a close relationship

"From that time on, the illustrious members of the theater had paintings by Vuillard in their boxes, because I acted as salesman," recalled Lugné-Poe, whom the artist shows here at the time they shared a studio at 28 Rue Pigalle.

between the theater and painting, but apart from David, Delacroix, and Paul Delaroche, artists who designed scenery and costumes were few and far between. The painter's profession was clearly separated from that of the set designer, and regarded as very much superior in the social hierarchy.

In fact, Vuillard's participation in the experimental work at Lugné-Poe's Théâtre de l'Œuvre can be ascribed to the emergence of a new mentality. Young

Since the beginning of his friendship with Vuillard, Lugné-Poe did his best to make the Nabis known, and went around Paris with their pictures. He sold some to the actor Coquelin-Cadet, the critic Jules Clarétie, and Prince Poniatowski.

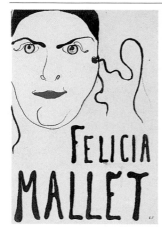

painters no longer felt that they were losing status by painting scenery. Some of them, and most of all the Nabis, tried out the devices they were using in their paintings within the confines of the stage set. Numerous literary critics and defenders of Symbolist theater, such as Pierre Quillard and Camille Mauclair, longed to see scenery that was composed "like a painting"; and this was precisely what Vuillard aimed to do.

For the frontispiece of Henri de Régnier's *La Gardienne* (*The Guardian*) (1894), Vuillard evoked the ghostly figure of the master's soul, appearing at the castle gates to tell him his destiny. For a long time Vuillard's interest in non-realistic drama was forgotten about; it seemed out of keeping with the tenets of late Impressionism that he seemed to adopt after 1900. Left, the disquieting figure of Félicia Mallet, as the young Pierrot, in the pantomime show, *L'Enfant prodigue* (*The Prodigal Son*) (1890) by Carré and Wormser.

The total work of art

The attempt to create a kind of drama that was free from the contingencies of realism can be linked to the trends of the time; intellectuals were moving toward a theater of the mind which was based on suggestion and rejected the precise reconstruction of time and place. In other words, one which could be everywhere and nowhere, so that attention was fixed exclusively on the psychological development of the characters and on the extremely tense relations between their "natures," which was the driving force for this type of drama.

Clearly Wagner was the inspiration for this turnaround; in his operas he aimed to create a "total work of art" which would include the whole combination of scenery, music, pantomime, the actors' movements, and an epic text. The torrent of Wagnerian opera was a far cry from the very short, usually one-act plays by Rachilde, Henri de Régnier, and Maurice Maeterlinck on which the Œuvre's repertoire was based.

Even so, Lugné-Poe did imitate the Wagnerian model by making the actors recite slowly and hypnotically, maintain fixed positions on stage, and use solemn, priestly gestures. He was one of the first to take the lead from the

magus of Bayreuth by having the lights put out in the auditorium in order to capture the audience's attention. Lugné-Poe also played a decisive role in commandeering Henrik Ibsen's plays for the Symbolists' camp, much to the fury, it must be said, of Ibsen himself.

The Œuvre venture

When the Théâtre de l'Œuvre company went to

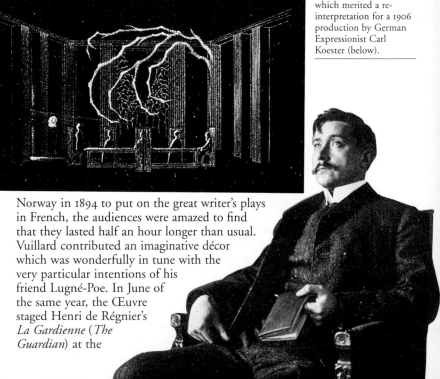

Maeterlinck's *L'Intruse* (*The Intruder*) (above) was performed at the Théâtre d'Art in May 1891, with sets by Vuillard. An oil painting on cardboard retains the sense of psychological tenseness that presumably marked this production, and which merited a re-interpretation for a 1906 production by German Expressionist Carl Koester (below).

Norway in 1894 to put on the great writer's plays in French, the audiences were amazed to find that they lasted half an hour longer than usual. Vuillard contributed an imaginative décor which was wonderfully in tune with the very particular intentions of his friend Lugné-Poe. In June of the same year, the Œuvre staged Henri de Régnier's *La Gardienne* (*The Guardian*) at the

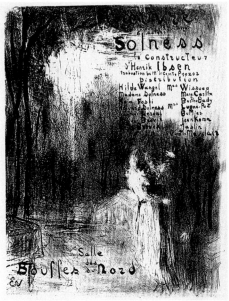

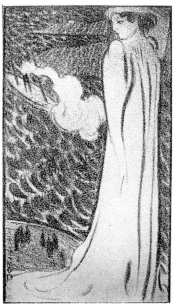

Comédie Parisienne. For this production Vuillard had the idea of isolating the performers from the audience by stretching a veil of tulle across the stage which made the actors' bodies seem ethereal, while the text was declaimed from the orchestra pit by other speakers. Not only did Vuillard, steeped as he was in Symbolist literature, make himself the inspired illustrator for this avant-garde theater; he also succeeded in organizing the reality he painted—intimate family scenes and strange enclosed settings—with the particular eye of a theater director.

When he created the scenery for Ibsen's *The Master Builder* (April 1894), Vuillard introduced to the theater the sloping stage which was to prove so popular with the German Expressionist drama of the 1920s. The effect that this created—of indicating the uncomfortable relationship between the characters and the ground they were walking on, and suggesting their psychological instability—was the same as that produced by some of the devices he used in his painting itself.

Paul Fort's Théâtre d'Art, then Lugné-Poe's Théâtre de l'Œuvre, introduced Ibsen's plays to France. For *The Lady from the Sea*, Maurice Denis showed (right) the melancholy Ellida peering at the horizon in search of the mysterious navigator, looking like a noble Pre-Raphaelite damsel (December 1892). Vuillard played much more (left) on the effect of shadowy light, barely revealing Hilda demanding "her kingdom," the castle of her dreams, from the architect Solness (April 1894).

Thus in works such as *The Goose*, the figures appear as if they were cut out from wood covered in fabric, and hammered in one on top of another with no concern for the illusion of depth. From the same period, *Man and Two Horses* recalls a painted cardboard puppet show, suggesting that the sheer simplicity of the materials must have driven the Nabi painter toward absolute two-dimensionality.

In *Le Sot du Tremplin* (*The Fool on the Springboard*) (1930), Lugné-Poe remembers these scenic innovations

with feeling: "In the third act, the scene known as 'Mrs Solness's dolls' led to protests. Vuillard, who loved the play as much as Maeterlinck, had created a set of incomparable splendor for that act....But when the audience saw it, they sat there like ducks looking at a knife. It was the first time that anyone in France had dared to set up a sloping springboard on the stage, facing the audience, to represent the terrace in front of the Solness home. The actors on this springboard were being crushed by autumn foliage, and you could see them moving one behind the other. Not one face was hidden. The actors can't have felt much at their ease, but that didn't matter. They all complained, but to no effect, I didn't give in."

> "Every masterpiece is a symbol, and the symbol can never endure the presence of man."
> Maurice Maeterlinck

In terms of their formal characteristics, Vuillard's synthetist works can be linked with his literary and theatrical interests. A love of pantomime and a nostalgia for children's toys are clearly apparent in *The Goose* (opposite left) and *Man and Two Horses* (left). Bonnard, Vuillard, and Sérusier also put on puppet theater shows, such as the performance of Maeterlinck's *Les Sept Princesses* (*The Seven Princesses*) at the home of State Councillor Coulon in 1892. Together with Alfred Jarry and the composer Claude Terrasse, they founded the Théâtre de Pantins (Puppet Theater) (1896 98).

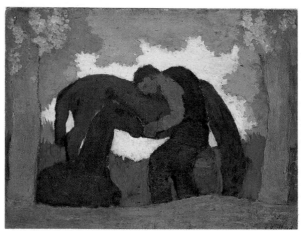

Vuillard's particular genius for painting scenes where the characters appear to be gliding along the ground as it slips from under their feet, and for stifling enclosed spaces, is closely related to the themes of Symbolist theater. Nocturnal scenes such as *The Dinner Hour*, and indeed *Interior, Mother and Sister of the Artist*, are attempts to illustrate the principles of Maeterlinck's theater, which, as he himself said, frequently gives its characters "the appearance of slightly deaf sleepwalkers who are constantly being woken up from a painful

The flattening of the space and the exaggeration of perspective heralded the devices that would be methodically used in the German Expressionist theater (opposite below, sketch by Ludwig Sievert for Strindberg's *The Highway*, 1923).

dream," and who together with the scenery form "a certain horrifying, somber harmony."

The theater of doubt

Of all the Nabis, Vuillard seems to have been the most wholeheartedly involved in the Théâtre de l'Œuvre venture. He was a co-founder of the company along with Lugné-Poe and Camille Mauclair, and was responsible for programs and set designs, on which he worked most intensely from 1893 to 1895. It is entirely possible, too, that he played a part in the aesthetic reversal of Symbolist theater, which in 1890–92 was very close to the rarefied excess of Pre-Raphaelite decoration, and also to the occultist, Neo-Gothic spirit of the Rosicrucians. The period of Paul Fort's Théâtre d'Art (1890–92), for example, was characterized by medieval mystery plays such as Quillard's *La Fille aux mains coupées* (*The Girl with Severed Hands*) (sets by Sérusier: "a gold backcloth framed by red draperies and strewn with multicolored angels"), Rémy de Gourmont's *Théodat* (sets by Maurice Denis: a gold backdrop struck with seven thousand red lions), and the esoteric *Cantique des Cantiques* (*Song of Songs*) by P.N. Roinard. Paul Fort went so far as to announce to his audiences: "From the month of March, performances at the Théâtre d'Art will end with the presentation of a painting as yet unknown to the public....The curtain will remain raised to reveal the picture for three minutes." (*L'Echo de Paris*, 30 January 1891)

With the advent of the Œuvre these affectations disappeared, making way for Ibsen, Strindberg, and Maeterlinck. Vuillard's stage designs resolutely reflect the contemporary world, in a spirit of modernity that is stripped of its political and sociological themes, but

In *The Dinner Hour* (above), Vuillard paints an extremely cruel scene in which he himself is relegated to a dark place on the doorstep and crushed by the family triad (mother/grandmother/sister), who are performing a strange nocturnal sacrifice and occupying the whole front area of the picture. The strategically placed candle in the back throws a mournful light on to the matriarchal group.

To varying degrees all the Nabis participated in productions of Symbolist theater. For the Théâtre d'Art Sérusier painted sets, and in March 1891 designed the frontispiece for Pierre Quillard's *The Girl with Severed Hands* (opposite page), a mystery which tells the story of a girl who wants to escape the "incestuous and brutal caresses" of her father, and is abandoned by him to the waves. Bonnard and Vuillard collaborated with Ibels on the sets for the triptych *The King's Epic Poem*; Bonnard painted the sets for "Fierabras" (above right,

whose strange proximity serves only to stir up the processes of identification which give rise to unease and terror.

In his memoirs, Lugné-Poe stresses several times how crucial a role Vuillard played in the Théâtre de l'Œuvre by his involvement in its set designs: "I may also add that of all those concerned, the person who from the first moment was most interested in the theater and the best general adviser was Edouard Vuillard, who often went with me to classes at the academy." Sérusier also recalled with admiration the particular way his fellow artist worked: "Vuillard would lay a large backcloth out on the ground, then, using a broom saturated with colors, seemed to spread them over in any old way, and then when it dried it became magnificent." It was probably because of his years as a set painter that Vuillard developed his tendency to paint *"à la colle"*—a technique in which powdered pigment is combined with melted glue or sizing—which had the combined advantages of economy and speed of execution.

the giant Fierabras in a tournament); the sets for "Roland" were anonymous and dominated by green and gold, while for *Berthe aux grands pieds* (*Berthe with Big Feet*), Vuillard and Ibels created purple rocks and golden rain. This little-known sketch (above), shows Berthe at the edge of the forest at the mercy of the cold and wild animals.

Nothing remains of the sets that Vuillard created for the Théâtre d'Art and the Œuvre. He did, however, leave behind many programs designed for these theaters, whose graphic style—hatched lines, wavy contours, blurred figures, and words swaying unevenly in the leftover space—is noticeably different from the principles of his normal painting.

For Vuillard, theater programs were a rare incursion into a violent visual vocabulary which he normally avoided. For Ibsen's *Un Ennemi du peuple* (*An Enemy of the People*), the turbulence of the words merges with the tumult of the angry crowd; in the frontispiece of Maurice Beaubourg's *L'Image*, a man is shown strangling his beloved because he is obsessed by the ideal creature of his dreams. Another work by Maurice Beaubourg, *La Vie muette* (*The Silent Life*) gave Vuillard the opportunity to show a mother protecting her children from the murderous rage of her husband. It may be that for

It was in an open-air studio at 23, rue Turgot that the Nabis painted their sets for Lugné-Poe. This was often a joint enterprise, so it is difficult to determine what part a particular artist played in any one set. Left, a frontispiece by Vuillard for *L'Enfant prodigue* (*The Prodigal Son*) (1890), with Félicia Mallet as Pierrot.

"Interminable discussions around the table in a café: fantastic projects for reforming the theater; sackcloth backdrops painted on the stage; the joy of projects that involved improvising on very little money; the unpredictability of dress rehearsals; and the always amusing surprise of audiences who were docile or scandalized, but never indifferent.... We believed that we could reform the art of theater set design."

Maurice Denis

the young painter, the often suffocating atmosphere of Symbolist theater offered a means of confronting the violent tendencies which are sometimes apparent just beneath the surface of his painting.

A disturbing strangeness

There is a clear connection between Vuillard's dark, expressionistic works such as *The Dinner Hour* and *Under the Lamp*, and the starchy, oppressive world of the plays by Ibsen, Strindberg, and Beaubourg which Vuillard and Lugné-Poe produced. In both cases one detects the active presence of the obsessive fears that haunted the painter: of confinement, solitude, and even castration.

For the young Nabi painter who devoted so much effort to it, this theater of doubt and the suspension of measurable time was the precursor to apparently intimate domestic scenes which he imbued with a silent,

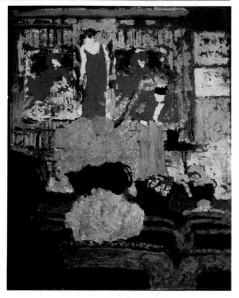

The Illusionist's Turn (c. 1895) (above) is one of those works that need to be gradually pieced together like a jigsaw puzzle. It is possible that the subject is the little theater at the Musée Grévin. It appears to show the end of an illusionist's performance where the woman has been made to disappear or be sawed in half. The woman is bowing to the audience, as is the magician (on the right), who has placed his top hat on a nearby table. Left, the program for Ibsen's *An Enemy of the People* (1893).

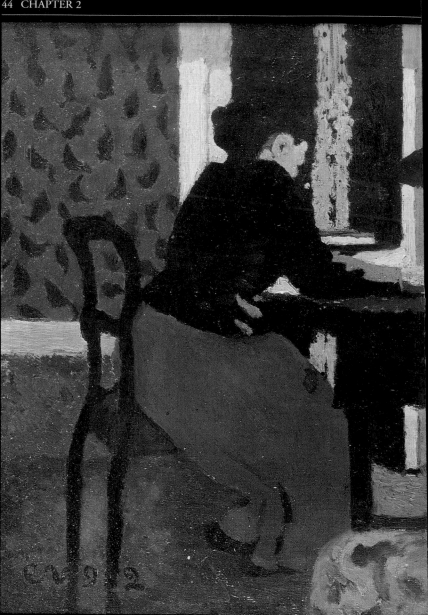

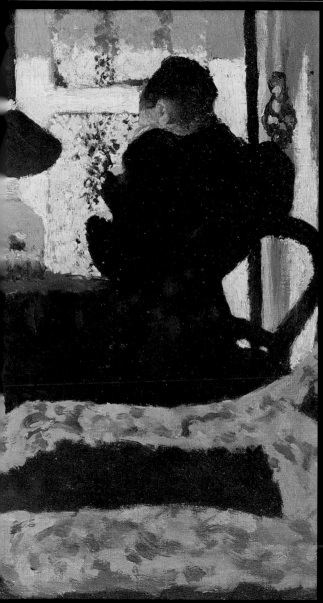

U*nder the Lamp* (1892) shows a private moment in the artist's apartment, with the artist's mother and sister as the obligatory protagonists. The overall atmosphere of the painting, however, is closer to the theater of Maeterlinck and Ibsen; we see a silent, stubborn tête-à-tête, the figures are viewed as a shadow show, or rather as inky blotches. There is an armchair tipping over in the foreground and blood-red wallpaper covered with a flight of crows, and the whole scene is lit by an implacable yellow light which foreshadows the principles of stage lighting at the Œuvre. When the artist designed the sets for Gerhart Hauptmann's *Solitary Souls* (December 1893), Alfred Jarry saluted "the mournful half-gloom surrounding the green lamp on the red tables where Vuillard illuminated the vegetative life that renders Kitty's hands so pale."

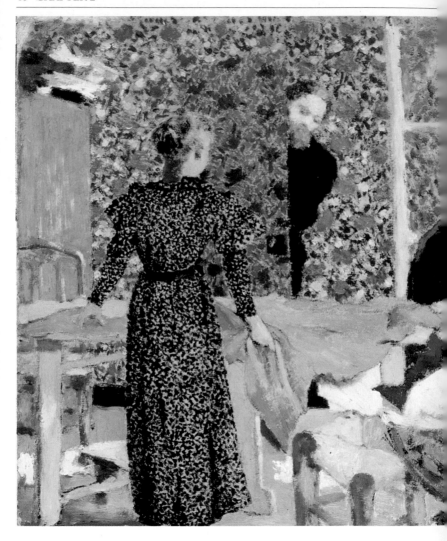

The furtive look that Ker-Xavier Roussel is giving his fiancée, Marie Vuillard, is one of the most moving images in the Nabi painter's oeuvre, a sort of visual confession of his affection for these two people who are so close to him. The way the future brother-in-law pops his face into the room like a puppet is an exquisitely witty gesture on Vuillard's part. Even so, the complexity of the collages of textiles and the unrealistic shower of flakes seen through the window take *The Suitor* far beyond the anecdotal into the realm of the universal; it reminded the critic Gustave Geoffroy of "the woolly reverse side of a tapestry."

unfathomable panic, and subjected to a sort of trance-like paralysis. Vuillard's particular liking for the theater of mystery did not prevent him from appreciating more popular entertainments and going out to cabarets. Like Bonnard and Toulouse-Lautrec, he frequented "Le Chat noir" and "Le Divan japonais," and a few months before the Œuvre's May 1893 production of Maeterlinck's mystical *Pelléas and Mélisande*, he did not consider it beneath him to go to the Théâtre des Bouffes Parisiennes to admire the serpentine, obscene contortions of Biana Duhamel as *Miss Helyett*—a kind of vaudeville version of the Marquis de Sade's "misfortunes of virtue."

Very different is the dancer Biana Duhamel, carried away by the sinuous dance of *Miss Helyett* (above). The lines come straight from the Japanese prints which Vuillard knew. In the case of the singer in *Divan japonais* (see page 9), recognizable as Yvette Guibert, Vuillard's extremely close-up viewpoint stylizes her face to the point of caricature, accentuates the garish light effects of the cabaret, and transforms her open mouth into a symbolic image of song.

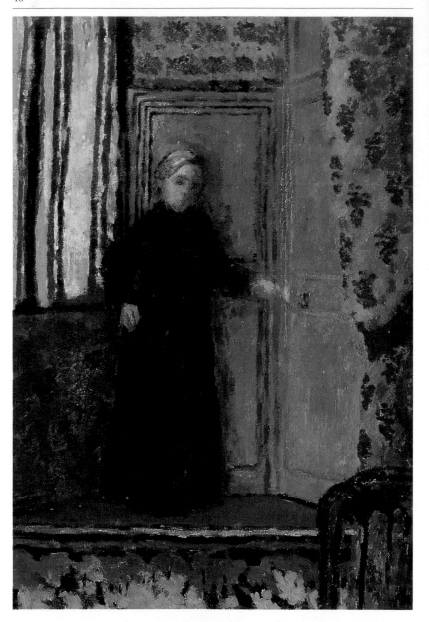

Vuillard resolutely carried out research toward linking the images which his memory suggested to him. He warded off his "daily tragedy" by very subtly combining places with the unfolding of his personal story, somewhat as if he wanted to test out the Bergsonian adage: "Perception makes use of space in exact proportion to the use that action makes of time."

CHAPTER 3

THE STRATEGIES OF THE ENCLOSED SPACE

The sudden entrance of a figure into the field of the picture always poses the same question in Vuillard's work about depth in painting, the separation of planes, and the interlocking of spaces. This detail from *Large Interior with Six Figures* (opposite) is a virtuoso demonstration of this phenomenon. Right, Vuillard at Thadée and Misia Natanson's home in Villeneuve-sur-Yonne (1899).

André Chastel, one of the earliest analysts of Vuillard's work, was right to view him as "one of those sensuous artists who make full use of their acute sensory perceptions." His painting is indeed deliciously paradoxical, its iconography shows the results of a strict Jansenist upbringing—family lunches, women corseted from veil to lace boot, scenes with children—while at the same time using different kinds of materials—lacy, striped, or dappled—to create effects which betray a profoundly sensuous nature.

The maternal idol

The figure he placed at the focal point of his universe, and who was his uncontested favorite as subject, was his mother. In the course of his life he depicted her in about five hundred paintings. It would be difficult to imagine a mother who made more effort to understand her son, to support him as discreetly as possible, and to bear witness from the shadows to the slightest development in his creative life. During his apprentice years it was she who organized the famous "Saturday roast beefs" to which he invited his friends Roussel, Ranson, and musician Pierre Hermant. Vuillard also entrusted her with overseeing the toning of his own photographs in soup plates. There are numerous mentions of his mother in his journal from 1888 to 1894, then from 1907 until her death in 1928.

During the Nabi period he often painted her with his sister, Marie. *The Chat* (1893) shows them as two separate, unbalanced expanses, one black and one

Edouard Vuillard was fifteen when his father died in 1883. Mme Vuillard ran a corset-making workshop, while the future painter's sister, Marie, as the daughter of a serviceman, became a boarder with the Legion of Honor. Above, Mme Vuillard and Marie on her wedding-day, in *The Chat.*

"[Vuillard] was the third child of an admirable mother who made her living from a business that made female knickknacks, in a dark mezzanine in Rue du Marché-Saint-Honoré.…She believed in her mission and devoted herself to it with almost unequaled confidence and self-sacrifice."
Pierre Veber, *Mon ami Vuillard*, 1938

white, confronting one another at the center of the picture, each one immured in her own way of thinking in an atmosphere where the air seems particularly rarefied.

Even more impressive is *Interior, Mother and Sister of the Artist* (1893), where Mme Vuillard forms a dark mass, rooted like a basalt idol to the ground, from which she seems to be drawing all her strength and power, while Marie, relegated to the edge of the room and bending over as if she were trying to retreat into the outer limits of the picture, blends in with the

Despite Vuillard's profound attachment to family life, it is possible to detect a horror of the norm in his work. Although seemingly resigned to the constrained atmosphere of the dining room with an aroma of cold coffee hanging in the air, his Expressionist vision bursts forth in *Mother and Sister of the Artist*;

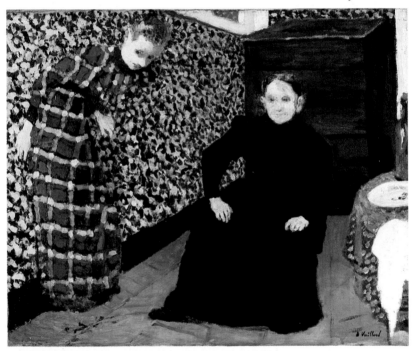

wallpaper like a timid chameleon. There is a marked contrast between Vuillard's early portrayals of his mother, all of which show her as a forbidding idol, and later paintings, which are considerably more reassuring and realistic.

the smallness of the room is exaggerated by the sloping picture plane, which consecrates the monumental presence of the two women.

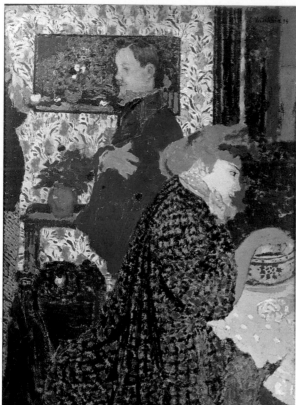

I n composing *Vallotton and Misia at Villeneuve*, the painter was no doubt aware of the gap that existed between Félix Vallotton's taciturn skepticism and the volubility of Mme Natanson. She was the only person who dared call the Swiss artist "Mon petit Vallo." Above, a photograph taken by Vuillard of Misia in the Rue Saint-Florentin apartment.

Terribly single

Vuillard was the most private of artists. Only once, in a journal entry in 1894 consisting mainly of anodyne details, did he confess to having told a secret: "On the way out, confided in Bonnard for the first time about my love. Sad." That was all, and we will never know for certain what he was talking about. The most likely explanation, however, suggested by the memoirs of Vuillard's friends (including Misia Natanson) and by reading into Vuillard's own works, is that he was secretly in love with Misia, the beautiful and capricious wife of Thadée Natanson. The Natanson home was a favorite

V allotton came from Lausanne, and was a late arrival to the Nabis. He made his reputation by producing caricatures for the *Assiette au beurre*, and satiric wood engravings of his contemporaries.

meeting-place for the whole avant-garde circle of Symbolists, Nabis, and Post-Impressionists.

Young, fascinating, and an inspired pianist, Misia was one of the muses of the Belle Epoque. She knew how to fan the flames of secret passion in Bonnard, Toulouse-Lautrec, and Mallarmé, and was more acutely aware of the power she had over the timid Vuillard.

In 1893, Vuillard saw his close-knit circle of friends embark upon married life; there were marriages between his sister and Roussel, Denis and Marthe Meurier, and Thadée and Misia. By his own admission, he more than ever felt "terribly single." He resigned himself to this position throughout his life; he never married or had children. And yet his world is a feminine world, or even a world of the feminine, in which men, if present, are reduced to the

Misia Godebska was accustomed to being surrounded by admirers. Her gifts as a pianist were such that Franz Liszt had noticed her as a child, and her teacher Gabriel Fauré wept when she announced her marriage to Thadée Natanson. Mallarmé dedicated poems to her. As the female inspiration for *La Revue blanche*, she held her salons either in Rue Saint-Florentin, Paris, or the house in Valvins, and later in Villeneuve-sur-Yonne. She claimed in her memoirs that one day Vuillard had made an awkward declaration of love to her. Whether or not that is true, they saw less of each other after 1900. (Below, a page from the artist's Journal, 1894.)

nai de 'ensommage

Attention se porte sur les hommes, je vois toujours

aigu un sentiment d'objets indicules. Jamais devant

we toujours moyen d'isoler quelques éléments qui

- peintre.

status of caricature, without a relationship of their own choice with the surrounding space. After a youth spent in his mother's workshop, and with his exceptionally introvert disposition, Vuillard always associated women with a world of fabrics, lace, and wallpaper, a textural universe which seemed to shun the presence of bare skin.

Marie Vuillard at her Window (1893) seems absorbed in gazing at something that we cannot see. Is she waiting for her fiancé, Ker-Xavier Roussel?

An arrangement of scraps torn from the past

Far from seeking to record the hum-drum routine of everyday life in the petit-bourgeois apartments of his time, Vuillard brings narrative modes into play with the unformulated intention of absorbing the materials which apparently reveal them. At times he seems to duplicate a number of objects in a painting, and thrust them forward in a fetishistic manner. And yet although these objects, these details pulled out from their normal trivial context, are always arranged in the form of fragments, they also seem closely associated with one single texture. In works from the Nabi period, the act of painting is identified with that of sewing or cutting out material, so much so that these pictures have been said by some to have a rhapsodic quality. Vuillard never succumbed to contemporary

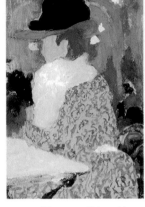

In terms of the subject, *Woman in a Bar* is one of the works that come closest to Degas and Toulouse-Lautrec; and yet the dress is composed like the tunic of one of Maurice Denis's seraphic women, or like Bonnard's famous *Peignoir* (Musée d'Orsay) with motifs placed against a monochrome background.

Vuillard's inner world is crystallized in the portrayal of work. One can feel that he delights in showing seamstresses absorbed in their work next to the window. No doubt this is the same room as in *L'Aiguillée* (*Interior with Women Sewing*) (p. 56); here, in *Woman Sewing*, the figure appears to be cut off amid the deluge of endlessly repeated flower motifs on the wallpaper.

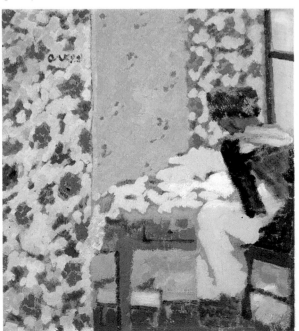

subject matter: urban scenes, streetwalkers, horses, carriages, in other words all that was dear to Toulouse-Lautrec, Anquetin, and Forain. What interested him was a more humble modernity, moving at a slower pace and containing inexhaustible secrets. Given that the sight he knew best was the dressmaker's workshop, and that since his childhood he had experienced its intimate rhythms and examined the mysterious processes whereby materials were sewn together, it is hardly surprising that his painting should appear as a montage of different planes, a union of heterodox surfaces. What is truly dazzling is that, despite everything, the consciously cerebral nature of the composition does not take over the moving emotional quality which transcends the merely visible.

One could even say that Vuillard had adopted Degas's maxim, "A painting is an artificial work which is outside nature, and demands as much astuteness as the perpetration of a crime." Once the initial tactile sensation produced by looking at a Vuillard painting has evaporated, what takes precedence is an intellectual admiration for the virtuosity of the composition, with its montages of fragments, episodes from the past, and arrangements of scraps torn from a memory which the artist knows is prolific.

In enigmatic paintings such as *Woman at the Closet* (1895), where the female form itself becomes one of the sections of the cupboard, we see that Vuillard was never confused by the ratio of scale between his figures and the decor that surrounds them. If anything, the relationship between the outlines and their environment becomes so close as to make the former lose their identity within the space.

"*Woman at the Closet* By blurring the features of his figures, Vuillard subordinated the identity of the laborer to the work itself, and conferred upon their work a sense of beauty and repose through a tight inter-weaving of line and color, of silhouette and pattern. In his paintings of the family in the interior, by contrast, Vuillard shifted his emphasis to the family members them-selves—their ambiguous, often troubled relation-ship with one another. The sense of intense privacy, almost of a secret language, that hangs over the Vuillard family addresses the Symbolist aesthetic as eloquently as the decorative language of the paintings of seam-stresses."

Elisabeth Easton

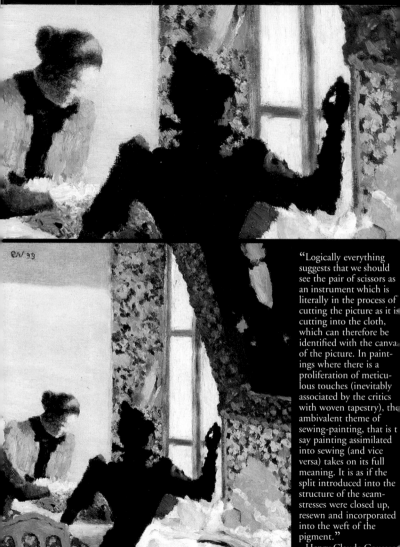

"Logically everything suggests that we should see the pair of scissors as an instrument which is literally in the process of cutting the picture as it is cutting into the cloth, which can therefore be identified with the canvas of the picture. In paintings where there is a proliferation of meticulous touches (inevitably associated by the critics with woven tapestry), the ambivalent theme of sewing-painting, that is to say painting assimilated into sewing (and vice versa) takes on its full meaning. It is as if the split introduced into the structure of the seamstresses were closed up, resewn and incorporated into the weft of the pigment."

Henry-Claude Cousseau
Ananth Deepak "Le
Ruses de l'intimisme
Vuillard catalogue, 199

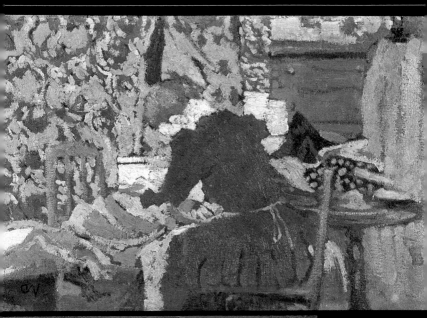

The delicate gesture of the needlewoman in *Interior with Women Sewing* (opposite page) pulling on the thread takes on a timeless dimension, no doubt because of the *contre-jour* lighting in which the painter places it. A portrait of a man seems about to topple over on to a jumbled heap of lingerie. Two other *Dressmakers* (left, 1890; above, 1893) show how far the artist had traveled in a short time, moving from flat, enclosed patches to the obsessional spotting of wallpaper and the complex inter-weaving of objects.

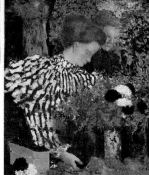

Many of the paintings of his youth are enigmatic, and need to be pieced together like a jigsaw puzzle. This is because the artist was rewriting reality on the basis of perceptions that were both subjective and fluctuating, recalling what Henri Bergson called the "involuntary memory." In the case of Vuillard it would be more accurate to refer to coagulated memories. As the philosopher says in *Matter and Memory* (1896): "In fact there is no perception that is not impregnated with memory. To the immediate and present data we receive with our senses, we add thousands upon thousands of details from our past experience. In most cases these memories shift the emphasis of our real perceptions, from which moreover we retain only a few pieces of information, simple signs destined to remind us of images from the past." Far from answering questions through his paintings, Vuillard simply shows the furtive movement of a certain number of objects which are shifted; or decentered simultaneously and randomly.

The Striped Blouse (left), one of five panels in a decorative group painted for Thadée Natanson in 1895, represents the ultimate degree of difficulty that figures and forms have in Vuillard's work to emerge from the decorative mass that surrounds them. The body becomes, as it were, the arena through which the differentiation of subject matter operates (the treatment of the stripes is particularly impressive in this respect), and it is virtually impossible to "read" each of the scenes at first glance.

The silence of crowded interiors

Most commentators on Vuillard's work have noted the musical resonance of his bourgeois interiors. Works such as *Room with Three Lamps* and *Misia at the Piano* have of course attracted particular attention in this respect. What is even more striking, however, in famous paintings such as the four panels for Doctor

Misia at the Piano and Cipa [her half-brother] Listening, absorbed in the music. Above the piano hangs one of the panels painted for Thadée and Misia, *The Album*.

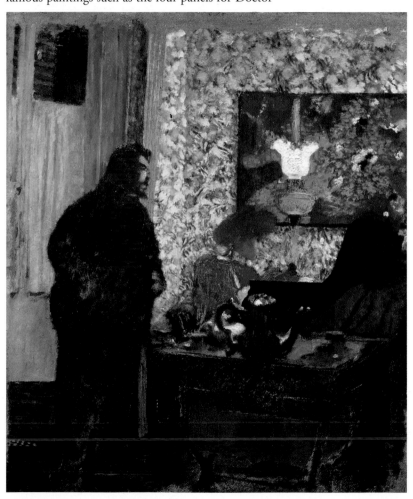

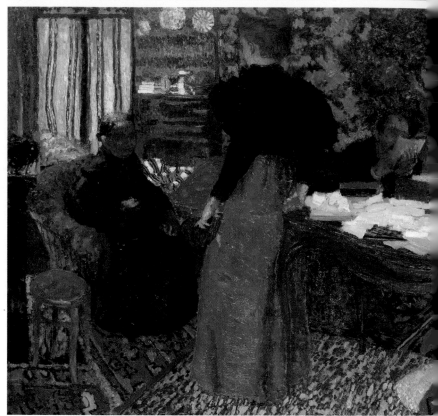

Vaquez (1896), is the exceptional, almost tactile quality of the silence that prevails in these over-crowded interiors. Works like *The Library* and *The Piano*, which have no depth or sound, and allow only for lateral movements within the enclosed area of the picture, display a style of painting which subverts its own intention. Here again, the artist echoes the thinking of Maeterlinck, who expresses similar ideas in *The Treasure of the Humble* (1896): "Words pass between men, but silence, once it has had the opportunity to be active for a moment, never fades away, and real life, the only life that leaves any trace behind, is made only of silence."

Vuillard gave this masterly *Large Interior with Six Figures* to Vallotton. He was probably showing a family dispute in the Ransons' living room, following the illegitimate relationship in 1895 between Ker-Xavier Roussel and Germaine Rousseau, who is shown standing and turning away in the left foreground.

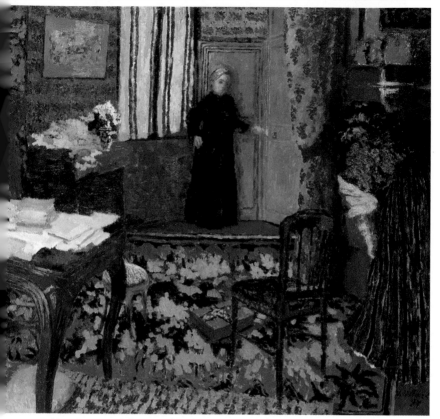

Large Interior, with its six characters in search of a reason for "being there," plays paradoxically on the combination of a chromatic cacophony due to the extraordinary overlapping of rugs, furniture, wall-paper, and mural tapestries, and the silence that is guaranteed by muffling the space with textiles. As if to bid farewell to the sequence of workrooms, it opens up a discontinuous, undulating space, thus giving material substance to the panoramic spread of memory.

When Vuillard does introduce the illusion of depth, as in *Interior at the Natansons' Home*, where the room seems to be dilated by the effect of the mirror, he is

In this painting one has the impression that the figures are unrelated and do not belong in the same space. Instead what is represented are three parallel, vertical bands delicately stitched together as three separate settings sewn into one. Throughout, the figures continually slip downward so that they appear as if marooned on the brilliant carpet.

merely setting a thought-provoking trap whereby
the sense of confinement is in fact intensified, as
Georges Rodenbach would express it some time later
in *The Reign of Silence*:
"And the love of the mirror, absorbing and deep,
Much saddens the room, which fears in its heart
That as evening approaches they do not agree,
For the mirror contains the room only in part!"

Mallarmé, the zone of tranquility

Vuillard, like Maeterlinck, and to an even greater extent
Mallarmé, believed that the mysteries of existence could
be revealed by paying less heed to people than to the
things that surrounded them. The fact that he knew
Mallarmé personally, however, adds little to any possible
poetic interpretation of his painting.

The very suggestive
half-light effects that
Vuillard achieves in some
of his interiors (below,
*Interior at the Natansons'
Home*, right *Interior-
Mystery*) are based on the
lighting techniques of
the Symbolist theater
(in particular a strong
light shining in from the
wings). The poignant
sense of distress ema-
nating from *Interior-
Mystery* may be an
allusion to the death
of the artist's nephew,
Petit-Jean, in 1896.

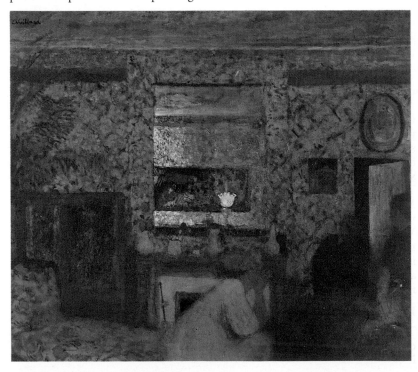

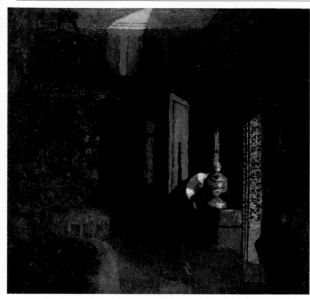

In his *Recollections of a Picture Dealer*, Ambroise Vollard recounts the answer that Mallarmé gave to the suggestion that Vuillard be asked to illustrate *Hérodiade*: "I am glad to know, my dear fellow, that I am to be published by an art-dealer. Don't let Vuillard leave Paris without giving a satisfactory answer. To spur him on, tell him that I am happy that the poem is to be made longer. For once that is true." When Vuillard learned at Valvins of his nephew's death, Mallarmé was thoughtful enough to accompany him to the train station. Below, a photograph of Mallarmé staring impassively at the camera, with the inevitable *plaid* (a kind of stadium blanket) on his shoulders and holding his pen like a scalpel.

Vuillard's nephew Jacques Salomon recalls that the artist attended the first reading of *A Throw of the Dice*. "He was taken aback by the performance, and the 'cult' aspect of the dining room in Rue de Rome put him off immediately. When we asked what impression the reading of the famous poem had made on him, he just smiled." The writer gave him a signed copy of *Divagations*, and the publisher Vollard wanted him to illustrate the *Hérodiade*. Mallarmé was delighted, but the project was suddenly halted by the poet's death. Vuillard met him several times at his home in Valvins, and sketched portraits of him in pencil. There is, however, a more subtle connection between the two men's work.

Rustlings of lost laces

The painter's calm, solitary exploration of the unknown had as its focal point the

apartment in Paris where he lived with his mother. It was this workshop, in which anonymous seamstresses went silently about their tasks, that provided a backdrop for his inner adventure. From this apparently closed world, the young painter tested how far the limits of the universe could be made to expand or contract; by withdrawing into himself, he began to explore the areas that might prove fruitful to him as a painter. Vuillard, it seems, was adopting Mallarmé's declaration: "Nature has already happened, there's nothing more we can add to it."

Like other *fin-de-siècle* artists such as Redon and Whistler, he was aware that any representation of reality was doomed to failure, despite the fact that the infinite resonances of an object can be understood fully through senses and mind. In his work resides a poetic of absence, a combination of fullness and emptiness which inevitably recalls the hermetic nature of Mallarmé's poetry: so much so that his paintings may well seem to be transpositions into another medium of Mallarmé's "rustlings of lost laces," "futile petitions," and other *sonnets allégoriques* of his own.

Even so, as Yves Bonnefoy remarks with regard to the poet, "the suggestion of the object does not take place in a vacuum; it recalls the object's forgotten integrity." Vuillard's Nabi painting, far from stagnating in the mire of conscious self-negation, moves ahead thanks to an almost obsessional affirmation of his known world. Its visible landmarks (armchairs, doors, wallpaper, sideboards) are objects "without quality," but serve as a focus for his subtle discourse on painting itself, in the same way as the "phonemes"

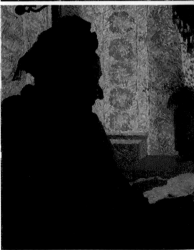

in Mallarmé's poetry purvey a superimposed meaning which enriches the image evoked by the word.

This explains the theme found in Vuillard's work of the mark impregnating the canvas, the merging of fore- and background and the flattening of perspective, all of which enables him to obliterate the reality he loves at the same time as he displays it. Far from being, to use Mallarmé's words, a system of thought lacking power to "resuscitate various memories," Vuillard's artistic vision introduces a highly original contraction of time within the hothouse of the picture, whose composition is often entirely unorthodox.

The delectable and the speculative

His continual efforts to depict the metaphors of a world of textiles only served to sharpen and entrench the analogy between the painted and the textural, thus

"At twenty-five, despite his freshness of spirit and his laughter, Vuillard had lost...any sense of being carefree; he was stable, logical and constantly in control of himself: never obsessed by sensuality, never led astray by the imagination." (Claude Roger-Marx). Vuillard was barely twenty-two when he painted this self-portrait (1889) (centre). Left, *Portrait of the Artist's Grandmother* (1890). Above, *Young Girl by a Door* (1891).

giving his apparently
fragmented work decorative
unity. As André Chastel
discerningly remarked:
"The deepening [resonance]
of the simple motif, which
means the end of earlier
imaginative developments,
originates in an impulse that
is both sensuous and abstract.
It requires a decorative
transition whereby the object
is inserted in its place, and
the forms are doubly
supported by the decision to
isolate them, and the desire
that they arouse and which
in its turn reinforces them."
A highly accomplished work
such as *Interior with Red
Bed* (1893) is the ideal response

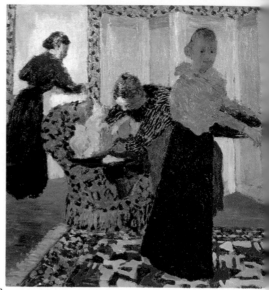

to the delectable and the speculative. Caught as if in
slow motion in the middle of their domestic tasks,

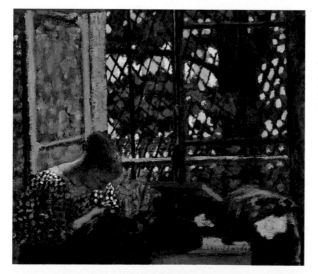

Above, *Interior with
Red Bed* (1893) can
be considered the
pendant to *The Suitor*
since on one sheet of
paper there is a sketch
showing both of them
(p. 115). Marie seems to
be preparing the nuptial
bedroom in the home
where she and Ker-
Xavier Roussel would
live from July 1893.

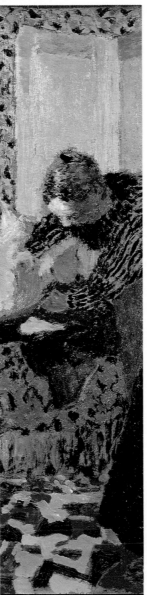

Cross-references between the many documents the painter left behind at his death (letters, Journal, thousands of sketches) throw a new light on Vuillard's creative existence. He turned his family life into a real artistic theme, strongly influenced by his love of Ibsen's plays. Having encouraged the marriage between Roussel and his sister, he went out of his way to show the different moments in their relationship as little dramas, sometimes of a tragic nature: flirtation, early marriage, moments of solitude for Marie (as in *By the Window*, opposite left), tense family discussions, death of a child.

the solemnly posed figures hark back to ancient Roman painting and medieval tapestry, with which an artist as well-educated as Vuillard would clearly have been familiar. For the young painter, this was a way of distancing himself some-what from these objects and the surges of sensuality that assailed his consciousness.

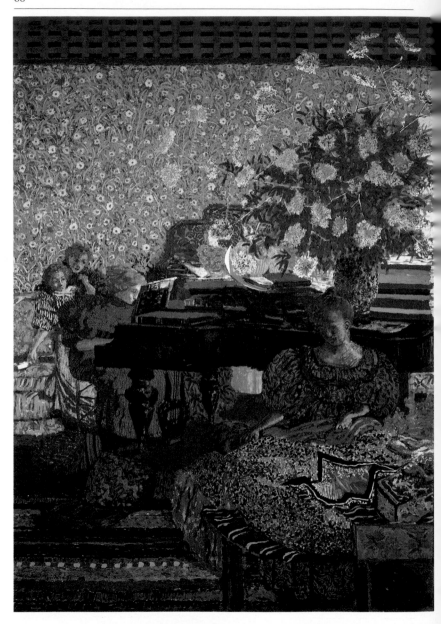

Vuillard's undisputed mastery of infinitesimal time, of imperceptible displacements, of the near-to-nothing and the whispered confidence, might seem to suggest that his talent could only be exercised in a small format. Given his command of impalpable forms and micro-organisms, it may seem reasonable to assume that he was destined to express himself with the utmost restraint. And yet, around the middle of the 1890s, he began to produce decorative paintings on a large scale.

CHAPTER 4
THE GRAND DECORATIONS

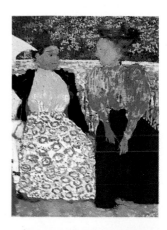

The Piano (left) is one of the four panels painted for Dr Vaquez in 1896; the other three are *Sewing*, *Woman Reading* and *The Library*. All four show moments in a feminine interior resounding with secret harmonies. Right, detail from *Public Gardens*.

From the beginning, the Nabis had tried to break free from the restraints of easel painting by looking for walls to paint: "The painter's work begins where the architect's leaves off...," declared Jan Verkade in *Yesterdays of an Artist Monk* (1930). With William Morris's Arts and Crafts movement in mind, they believed from very early on that their art was not limited to the flat surface, but should take in the whole of their visual environment: furniture, tapestries, wallpaper, vases, sculptures, etc. Being first and foremost a painter, Vuillard set out to "invent" all the combinations that a mural decoration had to offer.

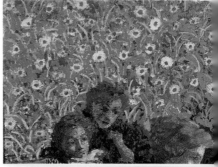

A "solitary Puvis"

From an early stage, commentaries on Vuillard's work pointed out the influence of medieval tapestry, and in particular the tapestries "of a thousand flowers" (*mille fleurs*), which he had discovered during his youthful peregrinations through museums. In addition he had an extensive knowledge of the great French painters of the 17th century, and had seen in the works of Le Brun and Vouet a "decorative facility" which he regarded as enviable.

There is no doubt, however, that the models to which Vuillard's large decorative pieces owe their virtuosity are the "murals" of Puvis de Chavannes. It is perhaps difficult at first sight to find any connection between Puvis's vast scenes filled with solemn, transparent figures, such as the great paintings in the Panthéon, or better still *The Sacred Grove*, and Vuillard's compact interiors showing his mother and sister going about their business against a background of dotted wallpaper. Nevertheless, what we do see is that Vuillard and Puvis shared a common love of purity and calm.

Maurice Denis had also shown that he was very much aware of Puvis's faculty for objectivizing the

"Visit to Cluny yesterday. Tapestries and missal illuminations.... As regards the tapestry, I think that purely and simply by enlarging my little panel I can make it the subject of a decoration. What humble subjects those Cluny tapestries have! They express an intimate subject on a larger surface, that's all. The same thing as a garden, for example."

Journal,
16 July 1894

Above, a detail from *The Piano* and a tapestry "of a thousand flowers" at the Musée de Cluny.

Certain neutral areas in the composition of *In Bed* (detail far below) refer to the abstracted forms found in works by Puvis de Chavannes, whose minimalist flat patches are almost non-painting. *See*, for example (lower below), the surface of the sea on which the small boat of the *Poor Fisherman* is reflected.

subject, and making form the matrix of the symbol: "Yesterday I visited the exhibition of Puvis de Chavannes's work. I found the decorative, calm, and simple aspect of his paintings very fine: a wonderful mural color: there are marvelous harmonies of pale tones....The measured, grand, ethereal composition was astonishing: it must require prodigious skill. It is that, no doubt, which leaves the sweetly mysterious impression on the soul, and which calms and uplifts" (Maurice Denis, *Journal*, 18 December 1887).

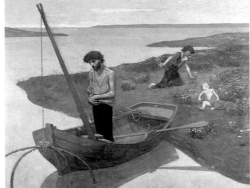

Even in some Nabi paintings it is possible to detect the influence of Puvis's subtle, suggestive style; Vuillard seems to have taken from the older artist a certain minimalism of form seen in the almost graphic stylization of his figures, and an ability to

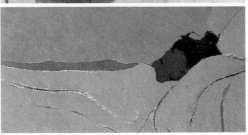

filter out any elements which might connect these with the modern world. Like Puvis's figures, Vuillard's seamstresses exist outside time. In both cases they are

doomed to move around silently within the frame of the picture, exchanging wordless gazes which betray a profound inner absorption.

Open-air intimacies

The influence of Puvis is even more evident, however, in Vuillard's first major decorative work, *Public Gardens*, a series of nine panels commissioned in 1894 by Thadée Natanson's brother, Alexandre, for his apartment in the Avenue du Bois de Boulogne (now Avenue Foch). These panels, long since dispersed, are generally regarded as one of the high points of Post-Impressionism.

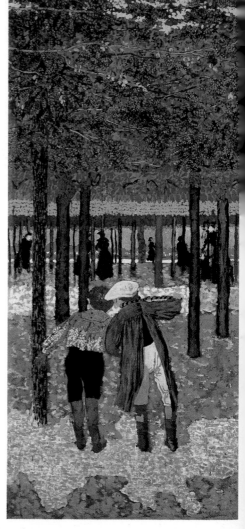

They still feature the usual Vuillard figures (nannies from the Auvergne, schoolboys playing hide-and-seek, well-behaved little girls), but here the artist's vision becomes progressively more panoramic, even though most of the paintings are still vertical in format. The figures are viewed frontally, but the ground is tipped up steeply so that it occupies almost two-thirds of the painting, with human beings who appear to have been placed on to its delicately shimmering ripples of gray, mauve, and gold. The meeting point of sandy ground and clumps of background vegetation creates a sort of continuous decorative horizon linking the separate panels. As a result there is no longer any empty space, any gap in the composition, as there was with the earlier *Desmarais panels*. Instead the figures appear to be

woven into the canvas, transposed into these "open-air intimacies."

In this way, Vuillard fulfilled the principle which critic Edmond Duranty subscribed to at the time of the second Impressionist exhibition (1876): "We will no longer separate the figure from the background of an apartment or the street." Vuillard's perception continued to be based on Duranty's modern approach, relying on the scene immediately before him and the evidence of

A number of sketches still exist that were done as studies for *Public Gardens*, including plans for their arrangement on the wall of Alexandre Natanson's apartment, where they all appeared to be windows opening on to an imaginary space. One of the most striking is the panel showing *The Little Schoolboys*, who just for a moment are staring into the distance at a ghostly ballet of shadows in the foliage of the Tuileries Gardens, which are transformed for an instant into a Symbolist undergrowth. The insight of children into the mysteries of the world is a constant theme in *fin-de-siècle* culture, and especially in Nabi painting. Throughout his life Vuillard showed his awareness of children's perception of space, and of their very particular selection of objects in which scale is a function of age.

the moment. The panels for Doctor Vaquez (1896), with their hothouse atmosphere and tapestrylike brushstrokes (the "definitive touch" that would be admired by Matisse), were a direct transposition of Vuillard's familiar, intimate world into a larger dimension, while at the same time remaining bound to the idea of the enclosed space.

The unfolding panorama

It was not until the turn of the century that Vuillard tackled his

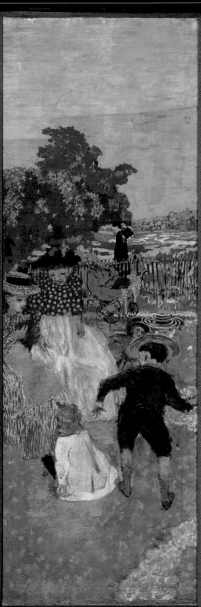
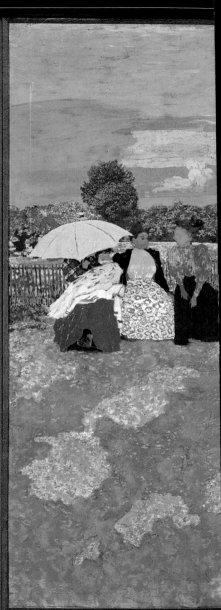

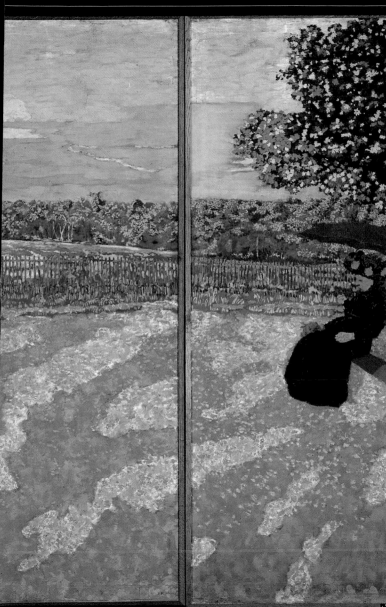

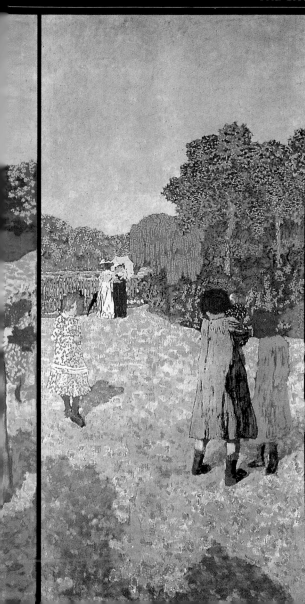

Public Gardens was originally divided up into nine panels. The ninth of these, *The First Steps*, has recently been rediscovered. Previous page, *Conversation, The Nursemaids, The Red Sunshade*, and left, *Little Girls Playing, The Questions*, and *Promenade*. With the continuing vegetation and gravel from one panel to the next, the impression of sequences seen from a central observation point was intended to be perfect, as was the illusion of a circular panorama unfolding to infinity. The color effects are some of the most dazzling that Vuillard ever achieved. Using the more rapid technique of glue-based tempera (*colle*) which he had learned from his experience in the theater, he produced, as critic Gustave Geoffroy put it, "magical bursts of light" with astonishingly muted colors. When asked by his friends about the shades he had used, Vuillard is said to have replied that he used "the worst ones. The ones I bought at the corner drugstore: English greens, dungaree blue and doughy off-white."

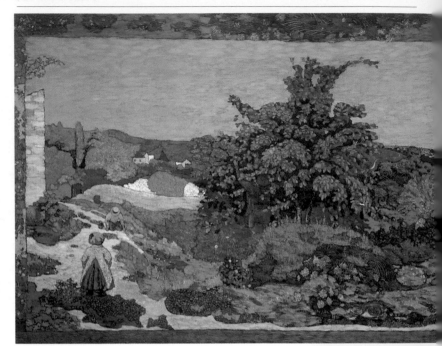

truly monumental compositions, of which *Landscapes.
Ile-de-France*, painted in 1899 for Adam Natanson, the
father of Thadée and Alexandre, is a virtuoso example.
In *Window Overlooking the Woods* and *The First Fruits*,
the artist unfolds a landscape over twelve feet in length,
framed by a border of vegetation taken straight from
the great murals by Puvis de Chavannes (in particular
Marseilles, *Gateway to the East,* and *The Sacred Grove*).
Like a projector screen whose image goes beyond the
frame, here nature is barely contained as it proliferates
and spills over the edges, engulfing the few figures who
venture into the scene.

The vegetation is transposed, almost artificial, and
composed of longitudinal, juxtaposed bands which
once again recall the techniques of tapestry. As Maurice
Denis remarked in connection with Puvis, Vuillard
metamorphoses leaves, tree trunks, and flowers into
architectural motifs, which he stylizes and repeats *ad*

The First Fruits was
not painted *à la
colle*, but in oil on
canvas. For a while it
belonged to the
collection of politician
Léon Blum.

libitum. The dominant green-gray coloring of these paintings creates a *contre-jour* effect, giving the impression that the human figures are continuously emerging from an eclipse.

During this period, the popularity of painting theories was beginning to wane. The entire Nabi group, although still very close friends, turned towards pictorial solutions which provided more scope both for atmospheric sensibility and for the

The panoramic spectrum of *Landscapes. Ile-de-France* (left) is so wide that one has the feeling that it is being viewed through a fish-eye lens. The monumental presence of the tree in the center and the rushing diagonal of the path at far right heighten the sense of this painting's concavity. Vuillard hides animals within this inextricable tangle of nature, seen as an ocean of faded greens

influence of Old Master painting.

Even so, Vuillard never took his easel to the country, and refused to paint from nature; at the very most he made constant notations on the little sketchpad he carried with him.

spattered with a few flowers in bloom, and bearing the painter's signature in the form of a peasant's red headscarf with white spots. Above, *The Little House at l'Etang-la-Ville,* painted at the same time as *Landscapes,* shows Vuillard's niece Annette stopped in her tracks by a pink landscape which is disintegrating and swallowing her up.

The conversion of the large-scale painting to an almost Impressionist aesthetic came to fruition in two great decorative series, first *The Haystack* and *The Tree-Lined Path* in 1907, but above all in the very beautiful ensemble for the "Bois-Lurette" villa at Villers-sur-Mer, painted in 1912. The filtered light effect that he managed

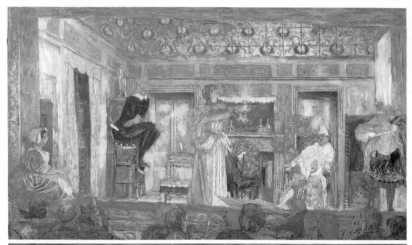

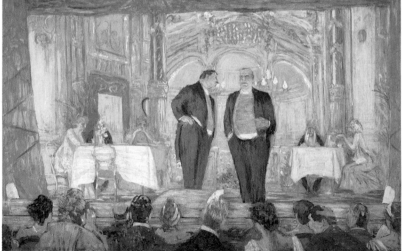

to create in *On the Terrace*, with two women convers-
ing under an awning, is one of the most absolutely
charming moments in Vuillard's oeuvre.

Oblique references to youth

The following year Vuillard was one of the artists
chosen to decorate the new Théâtre des Champs-

Above, classical
comedy, with a
scene from *Le Malade
imaginaire* viewed from
the auditorium. Below,
modern comedy, with *Le
Petit Café* by Bernard.

Elysées. The job allotted to him was in fact the smaller theater, the Comédie des Champs-Elysées. Here he created a group of paintings that were oblique references to his youthful days as a stage designer, painted in an allusive, sumptuous style that revealed the more conservative direction art had taken. The group of panels, *Le Malade imaginaire, Le Petit Café, Faust, Pelléas et Mélisande, Actors and Actresses Putting on Make-up*, along with some still lifes (*Punch and Judy, Flowers*), can be compared with contemporary paintings by Denis (*The Golden Age*) and Bonnard (*Decorative Panels for Misia*), in the sense that they represent a return to classicism. Vuillard's wit comes through in the way he shows the footlights shining on the actors, and nostalgia in the way he shows an aging Lugné-Poe putting on make-up.

In 1921–22, Vuillard produced the series *At the Louvre*, commissioned by Camille Bauer of Basel. The subject was particularly close to his heart, given the regularity with which he had visited the museum since his youth. When one considers the debilitated state of France after World War I, Vuillard's choice of subject takes on fairly clear nationalist connotations, suggesting that at this time he thought of himself as a staunch defender of the French tradition. The museum galleries he chose to paint also corresponded to the works for which he

Vuillard paid homage to Debussy's *Pelléas et Mélisande*, staged at the Opéra Comique in 1902, and later revived with the same sets by Jusseaume. Here the artist shows the very beautiful scene of the Fountain of the Blind, during which Mélisande loses her ring in the water.

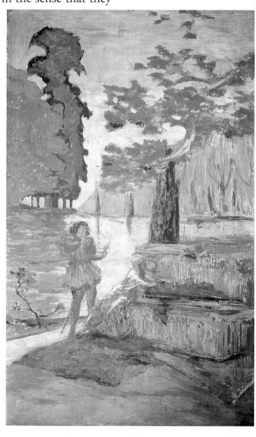

had a particular affection: the La Caze room to show 18th-century painting, and the Caryatids room for Roman sculpture. In addition to the obligatory tributes that pepper these paintings, the series enabled him to bring into play the problematics of the picture within a picture, which would become one of the hallmarks of his late style.

The classical temptation

Vuillard's conversion to classicism was in keeping with a sort of "return to order" among the Nabis, the early signs of which had been apparent in the years between 1910 and 1914. This tendency is normally associated with the reaction that took place in the arts after the end of World War I; and yet it is clear that after the experimental Nabi phase the work of Maurice Denis, Bonnard, and Roussel soon began to reflect the quest for a classical ideal, or to be more precise, what Denis was to describe as "the search for a classical order."

Vuillard always took part in their discussions, and was without any doubt deeply affected by them. At no time, however, did he seem willing to yield to the suggestions of Arcadia that filled his three friends' paintings at that time. His work remained entirely free of muses, ancient figures on the beach, Graces with peacocks, fauns pursuing shepherdesses, or any other subject that appears to stem from Antiquity. In short, although his style changed considerably, his iconography stayed more or less the same as it had been since the beginning.

Vuillard may have had in mind Degas's masterpieces *Mary Cassatt at the Louvre* and *Visit to the Museum* (1885). Among the visitors passing through the *La Caze Gallery* (right; sketch above), we recognize Annette Roussel on the right. On the wall are paintings by Largillière, Chardin, Watteau, and Fragonard, all from the 18th century to which Vuillard always had a particular attachment.

A timeless picture of an enthralled museum visitor, who is nevertheless very fashion-conscious.

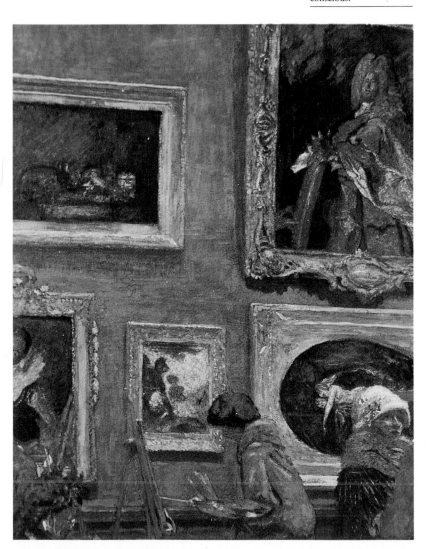

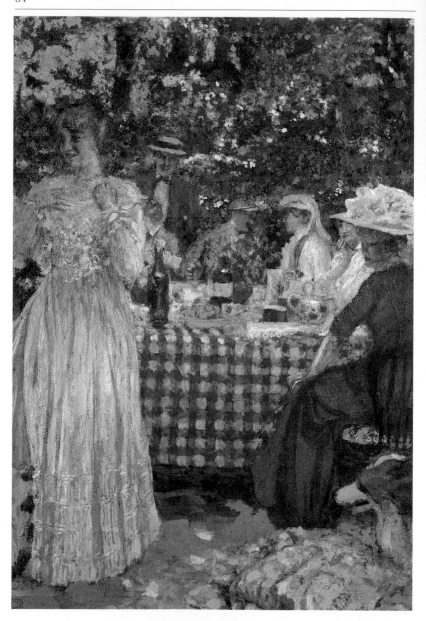

The first ten years of the 20th century give the impression that the artistic avant-garde caught up with Vuillard and then quickly overtook him. True, the work he had done in the previous decade was as much as many artists achieve in their whole lifetime. Even so, Vuillard was now over thirty, and already he seemed like an aging man amid the ferment of French artistic life before 1914.

CHAPTER 5

THE WORK OF TIME

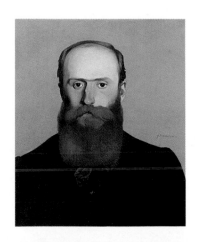

In 1902, Vallotton painted a portrait of his friend Vuillard which had all the sharpness, precision and accuracy of a Holbein. With his venerable red beard and his floppy neck-tie, Vuillard was beginning to look like a "savior" of French art.

The same can be said of the former Nabis, who remained Vuillard's close friends, and also seem to have found themselves stuck in an era where they no longer played a leading role. Bonnard used very simple terms to express his uncomfortable position during this period of transition: "The pace of progress speeded up, society was ready to accept Cubism and Surrealism before we had achieved what we had set out to do. We were left, as it were, hanging in the air."

A taste for the unfinished

Indeed, the concept to which they were all very attached—of the medium extended to the picture space, the canvas assimilated into the background, on which "the real painting" could be seen—had long since been accepted and overtaken. The difficulty was how to keep going and remain faithful to their original idea, without repeating themselves. It seems that for Maurice Denis, the time had come to remove any further doubt. In a famous article entitled "From Gauguin and Van Gogh to Classicism" (1909), he went to great lengths to condemn certain "errors" of his youth: "Under the pretext of synthesis, we have often made do, let us admit it, with hasty generalizations. By becoming more simplified, our art has become fragmentary and incomplete. We have produced many sketches and very few paintings. We don't know how

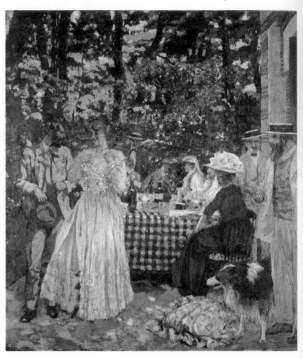

In *Lunch at "La Terrasse" in Vasouy* (1901), Vuillard began to show the influence of the freer technique of Monet and Renoir. This lunch in the garden (where we recognize, from left to right, Bonnard, Romain Coolus, Lucy Hessel, Tristan Bernard, and Gaston Bernheim) is only the right-hand side of a large panel which was painted for Jean Schopfer (a novelist who wrote under the pseudonym Claude Anet) and cut in two in 1935.

With *Homage to Cézanne* (1900), Maurice Denis seems not just to catalogue the Nabi group but to take stock of them, as they form an admiring circle around a still life by Cézanne and also around Odilon Redon: from right to left, Marthe Denis, Bonnard, Roussel, Ranson, Sérusier, Denis, Ambroise Vollard, André Mellerio, and, gazing absorbedly at Odilon Redon, Vuillard.

to finish anything, so be it; but even with the Old Masters, we prefer the rough outline to the finished work. Who will put an end to this perpetual state of over-eagerness, in which we are goaded on by the attraction of the new and our taste for the unfinished?"

In *The First Steps* (1900), he affectionately observes his niece Annette, the daughter of Marie and Ker-Xavier Roussel.

While Vallotton and Sérusier became progressively more entrenched in decidedly reactionary positions, Vuillard seemed to want to distance himself even further from the modern world, and retain the odd sort of freedom which was still very much his trademark in artistic circles. The journal he started to keep again from 1907 onward shows him as an indefatigable worker and an inveterate socializer. Between sittings with his models, he could be found having lunch with Tristan Bernard or Alfred Natanson, then going to an exhibition with Vallotton; in the evening, he would dine at Prunier's or go to the Ballet Russes, then at night it could be the cabaret Tabarin, where he went to find models.

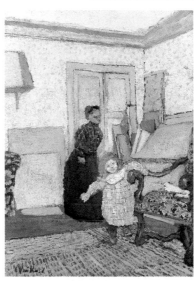

The new circle

One aspect of Vuillard's life which undoubtedly played an important role in the gradual move of his art toward Impressionism was his relationship with the Galerie Bernheim-Jeune. This gallery was one of the staunchest defenders of the movement, especially when it was under the aegis of Félix Fénéon. It was Vallotton who drew in Bonnard and Vuillard, but one can also see from the steady change in Vuillard's style that in 1900 he entered a different social milieu, at exactly the same time as he detached himself slightly from the decadent, anarchistic circles of *La Revue blanche*, which ceased publication in 1903.

His first one-man exhibition was held in the Bernheim-Jeune gallery in 1900. At that time he met Jos Hessel, who was associated with the gallery, and his wife Lucy, who gradually replaced Misia in his affections, especially after the latter left Thadée Natanson in 1905 to marry a multi-millionaire.

Whereas Misia had been the obsession and icon of his Nabi period, Lucy would become the dominant figure in his life, and in a style which little by little reverted to realism in its portrayal of objects and atmosphere. She slipped into the role of the artist's second mother-figure, protector, and lover, and he soon found that he had

Near right, Jos and Lucy Hessel (here at Rue de Rivoli), who after 1900 became the protectors of Vuillard's genius. They showered him with attentions, took him on vacation, and very soon formed a *ménage à trois* with him which was worthy of a boulevard play; Lucy (photo above) was the artist's lover and confidante for forty years. They frequently had violent arguments.

been taken in charge by the Hessels, who invited him both to their large apartment in Rue de Rivoli, and to their properties in Normandy or Brittany. All of this brought about very significant changes in Vuillard's day-to-day life.

The Hessel circle also introduced him to theater celebrities who had nothing in common with his youthful acquaintances such as Lugné-Poe and Berthe Bady; now he met famous theatrical people like Georges Feydeau, Henry Bernstein, and Tristan Bernard, who soon became his sponsors and who urged him, despite his nature, to become one of the figures of the Paris

Vuillard never ceased to love the theater. The series for Sacha Guitry's *The Illusionist* shows a singer, a cyclist, a fortune-teller, and of course, an illusionist. In this panel Sacha Guitry, Gardey the dwarf and his partner watch the play from the wings.

smart set. It was during this period that he created the magnificent group of panels for Sacha Guitry's *The Illusionist.* They were painted in distemper quickly and with incredible virtuosity, and showed the stage at the Edouard VII theater seen from the wings, with its protagonists: Sacha Guitry himself, his wife Yvonne Printemps, and Gardey the dwarf. With these panels, Vuillard was not only making an emotional gesture toward the paintings of Degas and Toulouse-Lautrec, who

had frequently shown the stage from the wings, but also paying a final tribute to the theater he had loved so much in the 1890s, when he too had spied on it in the same way.

In the years 1910–1920, Vuillard adopted a new way of organizing the pictorial space; although he remained very attached to the poetics of interiors, they now contained fresh air and light, which came in from all sides and ran over the surface of objects. He no longer disdained effects of depth, as can be seen for example in *Portrait of Madame Trarieux and her Daughters*, a sumptuous incursion into a domain more normally associated with Matisse. Here the focal length is foreshortened in such a way that the chairs in the foreground are almost pushed outside the frame, while the figures of the little girls are sunk into the rug and chair they are sitting on.

Vuillard had experimented before with this kind of optical foreshortening in the very striking *Child on a Rug* (1901), where the child looks as if he is being swept along like a small boat on the ocean, floating above the waves formed by the rug, which seems about to spill out of the picture. Likewise, in the very beautiful *White Living Room*, Lucy Hessel seems to be cut off at

The newspaper editor Jean Trarieux was close to Vuillard in his pro-Dreyfus, liberal views. The portrait *Madame Trarieux and her Daughters* (1912) plays on the contrast between the two peaceful areas of unbroken color and the untidy mess left by the little girls on the rug, which skillfully punctuates the space.

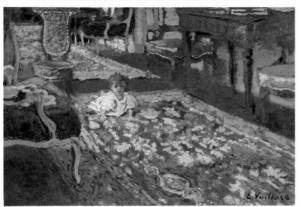

The *Child on a Rug* (left) is Michel Feydeau, the baby of the king of French farce. Lost on the shimmering surface of the rug, the child directs a questioning gaze at the real world. By this time the magical simplicity of Vuillard's petit-bourgeois interiors before 1900 had given way to the comfortable furniture and ostentatious luxury which from then on he preferred to have around him.

the far end of the room, while the furniture advances threateningly into the center of the field of vision.

The camera lucida

Undoubtedly it was Vuillard's experiments with photography that were largely responsible for the changes in the structure of his paintings. We have numerous accounts of occasions when friends were visiting him and he took out his portable Kodak to capture them in unprepared poses. By his own admission, "painting will always have the advantage over photography because it is done by hand," which would seem to exclude the possibility that he had any desire to pursue photography as an art in its own right. At most he would use the photo as an *aide-mémoire*, a sort of reference which

After 1900 Vuillard produced many images of nudes, painted from models who came to pose in his apartment in Rue Truffaut, then in his studio on Blvd. Malesherbes. Above, *Claire Cala* (1909) in a provocative pose à la Gustav Klimt.

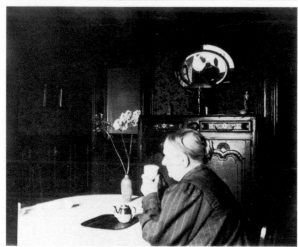

This very Fauvist, wild vision of the dining room in Rue de Calais may have been based on a photograph taken around the same time which, although more restrained, captures his mother in the same space. The photographic document was thus a stimulant to the artist's memory, enabling him to reconstruct the scene in his studio.

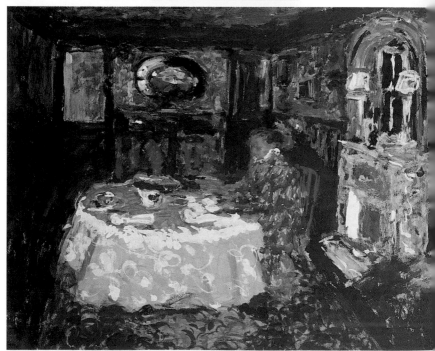

complemented the work he did when sketching in his notebook.

A large number of paintings from Vuillard's mature period come from an initial photographic approach to the subject. One example is *Game of Checkers at Amfreville* (1906), adapted from a high-angle photograph taken around that time. *The Haystack* (1907) is a sort of superimposition of two photographs, one of Marcelle Aron and Lucy Hessel sitting in front of a haystack, and the other of Tristan Bernard on a beach in Normandy. The figure of Tristan Bernard appears to have been picked out in contour and inserted into the first scene between the two women.

Other paintings play on the dividing effects caused by placing a mirror at the center of the field of perception. This is the case in a little-known work showing Sacha Guitry in his dressing-room, in which the infinite play of reflections deepens the enigma posed by the painting. Equally subtle is the *Portrait of Madame Val-Synave* (1920), in which the protagonist appears to be absorbed in contemplating her own image in the mirror; the only reflection Vuillard allows us to see, however, is that of the Venus de Milo sitting imposingly on the mantelpiece with the mirror immediately behind it.

There are also some paintings from these years that are completely atypical of Vuillard's work as a whole. One very strange work, painted during World War I, was *Interrogation of the Prisoner*, and he also produced a decorative ensemble for Lazare Lévy showing the oppressive atmosphere in the munitions factory when the machines were in operation.

"Mme Val-Synave arrived at Vuillard's home. She had come to have her portrait painted. As she looked at herself in the mirror above the mantelpiece, she asked Vuillard what pose she should adopt. Vuillard answered: "You're fine like that." And he immediately made a sketch…. He had devised his picture, now all he had to do was paint it."
Jacques Salomon

Modern vanity, meditation on the passage of time, a silent dialogue between sacred and profane love: all of these can be found in the *Portrait of Madame de Val-Synave* (above).

Proustian poetics

It has often been said that a number
of developments in Vuillard's work
during this period—the reintroduction
of perspective, the attention paid to
the atmosphere of places, the sense
of movement within the space, and
also the description of a more
fashionable world—were all signs of
the influence of Proustian poetics. No
doubt this is an over-simplification.
Biographical links between Proust and
Vuillard are virtually non-existent,
apart from their shared acquaintance
with the Bibesco princes, Antoine and
Emmanuel. Even so, there does seem
to be a remarkable affinity between
their sensibilities.

There is one passage from the
journal Vuillard kept in his youth,
where the painter allows his gaze to
move freely around the walls of his
bedroom, which already seemed to prefigure the
techniques of construction of Proust's *Remembrances of
Things Past*: "To sum up, not one of these inanimate
objects had a simple ornamental relationship with any
other, the whole collection was utterly disparate. Yet it
all had a distinct atmosphere, and gave off a particular
impression which I did not find unpleasant. It came as
a surprise when Maman, a living person, walked in. A
painter needs nothing more to hold his interest than
patches of color and forms." (26 October 1894).

Reading these lines it is impossible not to be
reminded of one of the early moments in Proust's
Remembrances, where the narrator is trying to recover
his self-awareness in the moments after awakening:
"And when I awoke in the middle of the night, since I
did not know where I was, I did not even know for the
first moment who I was." This difficult and sometimes
painful process of recognizing the world does indeed
seem to be one of the major features of Edouard
Vuillard's art, where he turns his apartment into a kind

In August 1914, Vuillard
was called up as a
military guard for the
railroad at Conflans-
Sainte-Honorine. He was
demobilized four months
later, then sent in 1917 to
Gérardmer as a war artist
for the armies of the
Vosges. It was there that
he painted this very
strange *Interrogation*, in
which we see a German
soldier standing in a
stupor next to a stove,
being interrogated by a
French officer whom we
can only just see in the
foreground in the
periphery of vision: an
austere, violent, almost
desperate image.

of besieged citadel, the only fixed focal point in the unstable universe that surrounds him.

Suspended memory

Thus every object, once it has been torn from its restful state of temporal and spatial indeterminacy, is filtered through this selective sensibility, aided by the distance of memory. Looking at the vases of flowers, studio nooks, and mantelpieces that fill the "late" works of the artist, one thinks again of Proust: "Elstir could not look at a flower without first transplanting it into that inner garden where we are forced to stay for ever."

Take for example *The Candlestick* (about 1900) and *The Mantelpiece* (1905), where Vuillard looks with amusement at the hierarchy of things. He appropriates objects and scatters them, and like people and places that at first appear to be separate, they end up betraying their secret unity, which is recovered precisely by the application of an endless gaze. Here again, the affinities with Proust's thinking are unmistakable: "The robust gentleness of that interposed atmosphere which has the duration of our lives, and is all the poetry of memory."

Annette on the Beach is the ideal expression of Proust's panoramic poetics; here we have absolute suspension of weight and total uncertainty of perspective. Moreover the figure lost in this scene of nature

Surprised as if in a snapshot photograph in the artist's attic in Boulevard Malesherbes, the young actress Lucie Belin (or Ralph) was one of Vuillard's great loves during the Great War. He tried in vain to find her work with his theater director friends. He provided her with material help until his death.

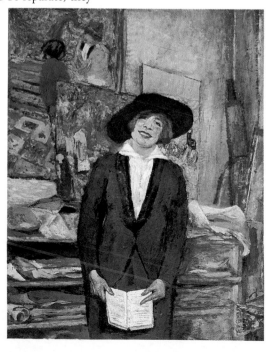

recovering its unity seems to break it up, not through a purely chromatic effect, but by a sort of irradiation of memory which seems to anticipate a passage in Proust's *Within a Budding Grove*: "I spent my time running from one window to another trying to bring together and mount on canvas the intermittent,

opposing fragments of my beautiful, scarlet, versatile morning, and to have a complete view and a continuous picture." Here there is a meeting between the indefinitely extensible field of the picture and a regenerated, expansive memory.

Like Proust, Vuillard was aware of the impossibility of humans being present to one another (many of his late family portraits show this emphatically), and so he invented a reversible time as the only effective means of wandering freely within the real. Since these wanderings were in the opposite direction from actual time, however, one has a sense that part of his work results from a skillful pictorial process of recollection, which was the only guarantee that his creative activity could continue.

Above, *The Mantelpiece* (1905), a meditative, quiet painting in which the work of time over a long period comes into play. Painted at Hessel's villa in Amfreville, this picture shows that Vuillard was now succumbing to his love of painting with depth, photographic foreshortening, and the more realistic portrayal of anonymous objects, in this case assembled fortuitously on the mantelpiece. Below, *The Straw Hats* (1909). On the beach in Saint-Jacut, Lucy Hessel is holding in her arms Denise Natanson, Alfred Natanson and Marthe Mellot's little daughter. The *à la colle* technique enabled Vuillard to apply great layers of color, foreshadowing the "All-Over" of Jackson Pollock and American Abstract Expressionism.

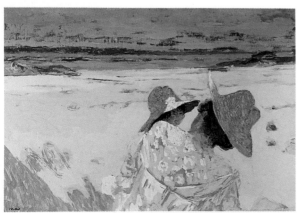

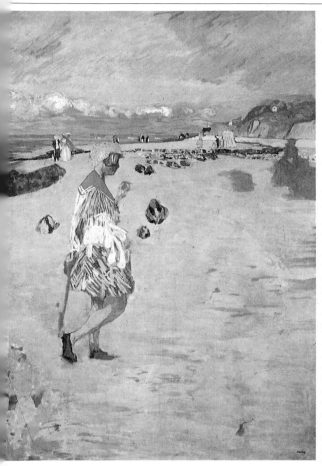

Annette on the Beach at Villerville (1911). Here Annette Roussel, Ker-Xavier Roussel and Marie Vuillard's daughter, who was shown at the age of two in *First Steps* (1900), is seen on a beach in Normandy, aged thirteen. Vuillard would follow her progress until her marriage to Jacques Salomon; she was in a way the daughter he never had. Always faithful to the relatives and friends he loved, Vuillard excelled at showing the imperceptible marks left by the passage of time, and the subtle links between the things that change—facial features, behavior, fashions in clothes—and the things that always remain the same. Few artists knew better than Vuillard how to recreate the intangible "music of the spheres" that makes the inaudible dialogue between souls possible. Can one love a person who changes? This question, which is central to all artists who function as self-sufficient "bachelor machines" (take Balzac and Marcel Proust for example, but also Marcel Duchamp), was resolved in Vuillard's case by recording what went on around him with a mixture of cynicism and resigned love.

Perhaps this is why, throughout his life, Vuillard's work continued to show the dual influence of a tactile appeal to the senses, and a heady hermeticism. It might be said that, right until the end, he went on subscribing to Mallarmé's declaration: "Every thought sends out a throw of the dice."

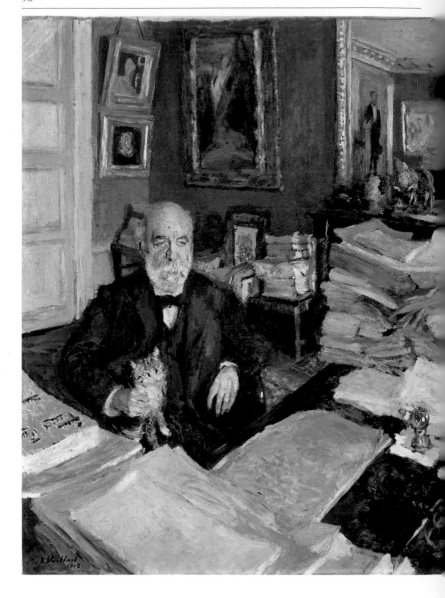

"Vuillard is a painter of modern life, but not an anecdotal painter. His work is a chronicle of Parisian life; it is the mirror of a civilization;… it is a defense and an illustration of French realism which seals the peace between man and the world, and between man and other men."

Waldemar George, 1938

CHAPTER 6

IN PARADISUM

Théodore Duret (left) offered Vuillard the opportunity to paint one of the first portraits in his late style; note the intellectual concentration of the model, the jumble of papers summing up his life, and the slightly tipped perspective. Here the defender of the Impressionists and friend of Manet is shown at the age of seventy-four. In the reflection in the mirror we see his portrait by Whistler. Right, detail of *Portrait of Jeanne Lanvin*.

The long twilight of Vuillard's career was not a slow death agony. Just as he had been deaf to the siren calls of abstraction and Cubism from 1910 to 1920, he pursued his own course imperturbably until his death in 1940, remaining relatively indifferent to the triumph of classical forms which began in the 1930s. His style was now much more finished, his detractors would say too slick. Going completely against the provocative statements of his youth, he systematically worked in local colors, modeling his forms with small brushstrokes. Whereas the Nabi painter had synthetized the sights before him, he now produced an inventory of reality, recording the slightest sound of a clock or rustle of foliage and reproducing even the smallest picture that hung on the walls of the collectors he painted.

In some works this cataloguing of the tiniest details became obsessional. In one extreme case he

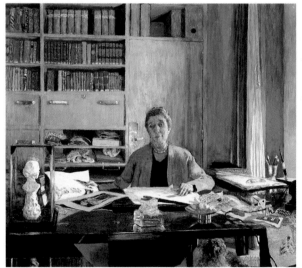

drove the Comtesse de Noailles to hide her jar of vaseline because "Mr. Vuillard paints everything he sees." Despite everything he was remaining true to his philosophy of creation, insofar as he was still going

One of the most structured portraits of this period is that of Jeanne Lanvin, a fashion designer in the inter-war years. The room is criss-crossed by horizontal and vertical lines which convey the model's love of order and precision, while her face expresses the intelligence and humanism of a woman of breeding.

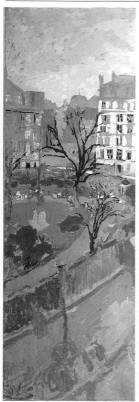

back to a principle of Bergsonian philosophy: "In the end, seeing is nothing more than an opportunity to remember."

Place Vintimille

Although he made a number of trips to England and Holland, Vuillard always came back to haunt the same

In 1908 Vuillard moved to 26 Rue de Calais on the corner of Place Vintimille. From then on he made paintings of this microcosm of Paris, which was like a circular Tuileries Gardens in miniature. Here (center) a very free sketch from 1908, with splashes of paint applied *à la colle* which was intended as a

places. In 1926 his building in Rue de Calais was put up for sale. He and his mother moved about fifty yards away to another apartment in the Place Vintimille which was to be his last home: As Jacques Salomon remembered: "For weeks, Vuillard looked on with feeling as the Rue de Calais was demolished. Day by day he watched the work progress, and when the pickaxes reached his floor and the rooms where he had lived for twenty years were exposed, when he saw the doors, wood paneling and mantelpieces disappearing into a heap of rubble, he was moved to tears." When his mother died in 1928 he was immediately taken in by the Hessels, and from then on divided his

preparation for a diptych for Henry Bernstein (1909) and inspired a five-paneled folding screen for Marguerite Chapin. This little square with a garden containing a statue of Berlioz offered Vuillard and his mother (seen above in a photograph taken by Jacques Salomon in 1927) a discreet retreat from the world, even though it had windows opening on to the noises of the city.

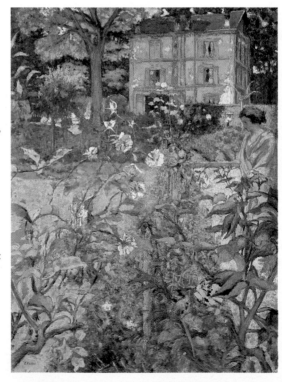

time between his apartment in Place Vintimille and the Château des Clayes, which his patrons had bought in 1926. More than ever, Lucy Hessel took him under her maternal wing: "How can one possibly keep count of all the paintings that show his lady protector standing, leaning on her elbows, sitting at a table, lying down, reading at the window or under a lamp, looking into the mirror or bending over a log fire, taking her big dog for a walk or arranging flowers, in casual clothes or a low-cut dress, bareheaded, wearing a hat, with brown, gray or white hair?" (Claude Roger-Marx). Because of her the artist, whose existence to date had been a subtle combination of monastical retreat and a very active nightlife, accepted the glittering, bourgeois life to which she introduced him. He also accepted, with amusement, the special culture of the poker players, racecourse gamblers, bankers, and investors who formed the Hessels' clientele.

The Hessels' country house, *Le Clos Cézanne à Vaucresson*, became one of Vuillard's havens of peace between 1920 and 1926, before his protectors bought Château des Clayes to entertain their rich and careless friends.

Stroke by stroke

Between 1920 and 1940, Vuillard was the best-known portraitist in Paris, with a nouveau riche clientele who fought over his services. His earlier portraits had been more like caricatures, painted in the simplified, synthetic "Nabi" style. Now Vuillard's art gained in subtlety what it lost in radicalism; he made it his special purview to emphasize the psychological links between the figure and

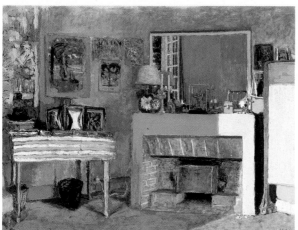

The combination of geometrically assembled flat surfaces in pale blue, brick red, and yellow is daringly aggressive. Left, the *Room in the Château des Clayes* (1933), where incandescent lights have given way to electric lamps. This would become one of the last observation points from which the artist re-created the world—witness the works in progress on the walls.

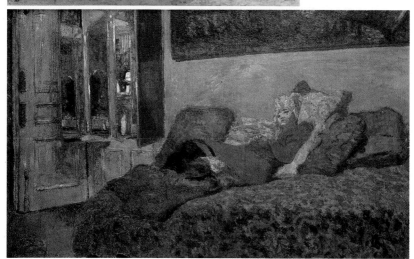

environment. As Romain Coolus remarked: "The artist casts a particular beam of light on to the individual shown; but for him this individual is just one of the whole collection of objects which make up the private world to which he belongs. He is refracted into everything that surrounds him; his tastes and preferences are etched into the furniture he uses every day,

Madame Hessel Lying on the Divan (c. 1920) expresses all the luxury and indolence of life in the Hessels' bijou apartment.

and in all the details of the decor in which he spends his life."

It is clear that in his old age Vuillard attached more importance to deep psychological understanding and moral introspection than to the interplay of textural complexities which in the past had been his main concern. He now aimed to join the great portrait tradition of Van Dyck, Gainsborough, and Whistler.

What was special about the way he viewed people was perhaps the fact that he treated them as still lifes, with the result that they became psychological types: the investor, the industrialist, the doctor, the actress. As the artist himself said: "You start a portrait without knowing the model; when you have finished it, you know the model, but the portrait no longer resembles him." His virtuosity enabled him to produce some portraits at very high speed; others, however, such as the famous portrait of the Comtesse de Polignac, took months or even years to paint. Just as Pierre Bonnard continually retouched and improved his interiors and panoramic views of Le Cannet, so too Vuillard liked to return to some of his likenesses, sometimes even making modifications to signal the passage of time.

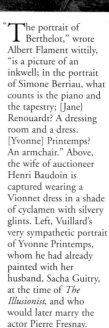

"The portrait of Berthelot," wrote Albert Flament wittily, "is a picture of an inkwell; in the portrait of Simone Berriau, what counts is the piano and the tapestry; [Jane] Renouardt? A dressing room and a dress. [Yvonne] Printemps? An armchair." Above, the wife of auctioneer Henri Baudoin is captured wearing a Vionnet dress in a shade of cyclamen with silvery glints. Left, Vuillard's very sympathetic portrait of Yvonne Printemps, whom he had already painted with her husband, Sacha Guitry, at the time of *The Illusionist*, and who would later marry the actor Pierre Fresnay.

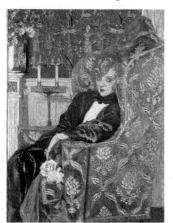

"You're making jewelry"

"...I paint people in their homes," said

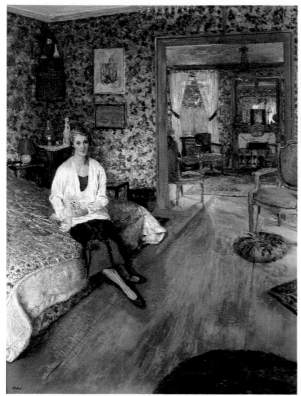

Jeanne Lanvin's daughter, the Comtesse Marie-Blanche de Polignac, was a distinguished Baroque singer and friend of Ravel and Poulenc. In this portrait from 1932, Vuillard shows her in a relaxed posture, sitting on her bed, surrounded by the objects that are dear to her, and to which the artist has given his legendary attention. The imbalance of the composition caused Jean Giraudoux to remark that the countess was "viewed through the narrow end of the lorgnette."

Vuillard laconically. And indeed, a favorite theme seen time and again is that of the woman captured in the privacy of her boudoir, in a quiet alcove, or in the upholstered silence of her living room. One example is *La Comtesse Jean de Polignac*, where the Countess is shown sitting with a little dog on the edge of a bed in her country house; the de-centered composition suggests that its real subject may be the deep recession, which allows a glimpse of a mantelpiece at the far end of the room. The mirror above reflects the expanse of space which is gradually perceived.

Vuillard also liked to show the effect of electric light on enclosed interiors, as is shown in the very

beautiful portrait of
*Madame Hessel Lying on the
Divan, rue de Naples*, and in
another of *Princess Antoine
Bibesco*, in which he used
more Fauvist colors than
usual and showed himself the
equal of Boldini by using
sweeping brushstrokes which
left a great deal to chance.
Few portraits gave Vuillard
as much trouble as the
very famous one of the
Comtesse de Noailles, in
which he showed her ill
and sitting up in her Louis XVI
bed, writing and surrounded
by a multitude of objects
which he skillfully recorded.
Apparently, when Bonnard

The Comtesse
Lanskoy was the
mistress of Marcel
Kapferer, the president
of Shell-France and a
generous patron of
Vuillard.

"[In the bold ideas of
young artists], in their
feats of daring, he always
took a loyal interest.
Bonnard always filled
him with wonder. As for
Picasso's experiments
and the great forces of
discontentment or
destruction that were
brought out by
Surrealism and Cubism,
he was far from dis-
puting their importance.
'Having nothing of the
revolutionary about
him,' as he himself
liked to say, he did not
deny the benefit of
revolutions. His goodwill
toward beginners was
great."
Claude Roger-Marx

saw the picture he could not resist exclaiming: "I say, Vuillard, you're making jewelry!"; beginning at this time, however, some critics started attacking him for using vulgar, garish colors.

Ultima verba

In his twilight years Vuillard also excelled at showing inspired businessmen seated at their desks or surrounded by heaps of papers, or in some cases as enlightened art lovers, sitting imposingly amidst their collections of *objets d'art* and paintings. While Dr Gosset is seen operating on a patient in his clinic, and Dr Vaquez is visiting his patients, Vuillard shows vice-minister Berthelot working late in his office at the foriegn-affairs ministry (1928). The sumptuous portrait of actress Jane Renouardt, on the other hand, gave him the opportunity to make a display of barbarous luxury by using the effect of infinite reflections in the mirror to expand the confined space of her bathroom.

Despite his preference, shown here, for rustling fabrics and a combination of purple shades and silvery reflections, he still reverted occasionally to a more austere mood, as can be seen from his famous *Portrait of the Artist Washing his Hands* of 1924 (p. 111). Here he appears infinitely melancholy or even pessimistic--an aging reflection in the mirror, surrounded by the historical reference points of his art, which are like a

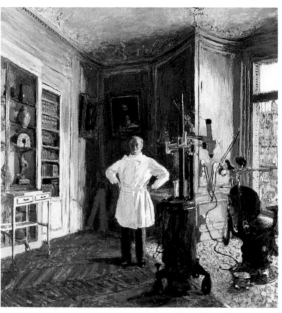

Dr Louis Viau in his Dental Office (1937) is Vuillard's last portrait of the medical profession. He achieves a "harmony of white and gray" in the manner of Whistler; the light falls on objects with almost surgical precision. The rather absurd arrogance of the doctor in the middle of a threatening hodge-podge of objects did not escape the artist, who loved to create voluptuous combinations of materials: rugs, bakelite, gloss paint, cloth, copper... (Pages 108–9, *Philippe Berthelot* and *Jane Renouardt*).

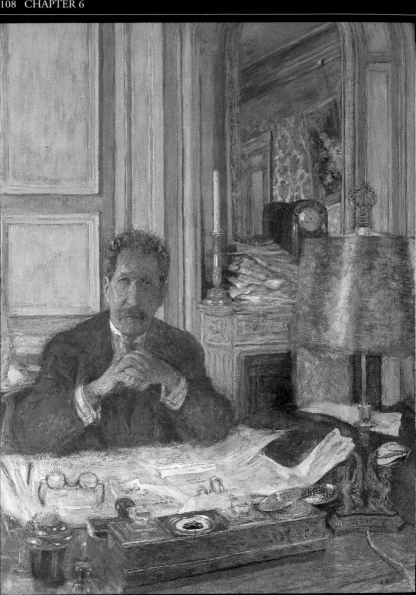

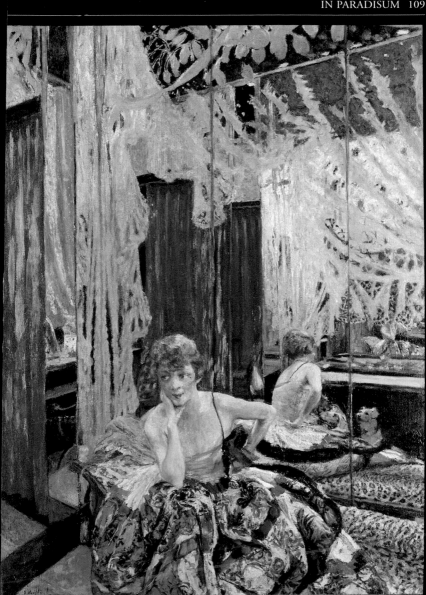

many-colored casket enclosing the sight of his emaciated likeness.

In the last ten years of his life, Vuillard saw the consecration of his career as a painter. Despite his natural tendency to shy away from official honors, in 1937 he yielded to the entreaties of Maurice Denis and took over Paul Chabas's seat at the prestigious Institut de France. He was given the responsibility of writing a report on the proposal to send students from the Académie de France to Rome, a task which he carried out scrupulously. He then received his first commissions from the state; *Comedy*, a decoration for the Théâtre de Chaillot, and *Peace, the Protector of the Muses* for the League of Nations Building in Geneva (1938), which enabled him once more to evoke the memory of Puvis de Chavannes. In the same year a large retrospective of his work was held at the Louvre, in the Pavillon de Marsan. This gave the general public the opportunity to rediscover his works from the Nabi period, and admire the monumental decorative paintings in the central hall.

"During the exhibition, from May to July, a respectful half-silence was observed by the critics; in general they were somewhat reticent about the last fifteen years," as Claude Roger-Marx relates. Thus the official sanctification of Vuillard's career coincided with its eclipse in the world of avant-garde criticism.

Deeply shaken by the capitulation of France to the Germans in the attack in

Left. *Winter Garden with Peacock* (1939–40) is an icy vision of the park in Les Clayes, painted while France was at war with Germany. This was to be Vuillard's last winter.

The panel for the new Théâtre de Chaillot, *Comedy* (1937), inspired Vuillard to fill the forested property in Les Clayes with characters from the plays of Shakespeare and Molière (Bottom, Oberon, Titania, Scapin, a marquis, and an ingenue, some tree caryatids…), and soft shades of green which only he could produce. Jacques Salomon recalled that he was only moderately impressed by Bonnard's adjacent *Pastoral*, which was more resolutely modern in inspiration and technique.

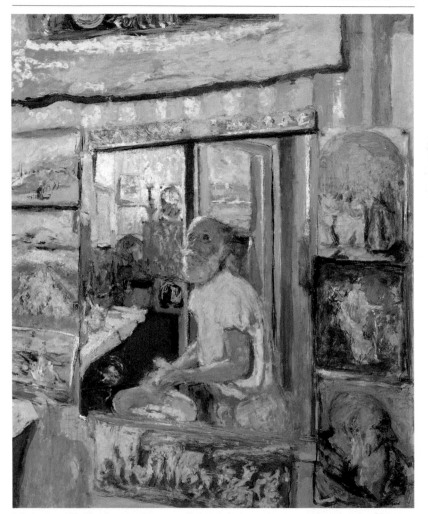

May 1940, Vuillard was taken away from Paris and any further bombing by the Hessels. He died of pulmonary edema (fluid on the lungs) at La Baule, on 21 June 1940.

Portrait of the Artist Washing his Hands (1924). Around the mirror, Michelangelo's *Zacharius*, *Flora* of Stabia, Le Sueur's *Raymond Diocrès*, a Poussin drawing, and Hiroshige's *View of Edo*.

DOCUMENTS

Vuillard's own view of things

Vuillard kept a private Journal from 1888 to 1895, and from 1907 until his death in 1940. The early notebooks are a collection of fleeting impressions, subjective opinions about aesthetics, doubts, and aspirations, interspersed with sketches of paintings in the Louvre or street scenes. After 1907 they are more diary-like, providing a record of the artist's activities from day to day.

The entries in Edouard Vuillard's Journal are not of the same literary quality as Maurice Denis's articles. They are hastily scribbled, and the spelling and syntax are chaotic; some words are underlined. Despite their telegraphic style, they provide useful insights.

We perceive nature through the senses which give us images of forms and colors, sound, etc. no form or color exists except in relation to another. Form on its own does not exist. We see only relationships. Painting is the reproduction of nature seen in its forms and colors thus of the relationships between forms and colors. For that I

transfer my eye which has just grasped a relationship of form or color on to the paper or on to the canvas I have to find the same relationship—if I fix on some point or other I end up looking at some body or other.

20 November 1888

The countryside in the evening is completely absorbing; big lines, big shapes; big, that is to say simple; in the country a large space is captivating why? yet it is the same phenomenon that occurs in a bedroom when you look at an object and sense its form and color: in that case you need to have a predisposition; in the other you are led to it by the vastness of the expanse you have to run your eye over; this process increases the tendency simply to see a form. What is simplicity? A thing that can be easily understood? When a thing is huge it can only be understood if it loses its details and predisposes you to sense the larger relationships. Or could it be the fact that it's something you're not used to looking at? That makes you see the larger relationships before the smaller ones?

31 August 1890

(We experience pleasure when looking at a form, or a group of colors, because we only <u>see</u> them) so the pleasure is the state in which we <u>see</u> we are <u>taken over</u> by a sense impression; the opposite the state in which we cannot hold on to an idea a sense impression? But some sense impressions are stronger than others? One is more or less taken over. and the pleasure is the moment itself; but immediately afterward the <u>memory</u> is still agreeable (the reliving of the whole experience which we merge in our minds with the first <u>moment</u> and which it is only wrong and pointless to seek if the first did not exist).

31 August 1890

26 Nov. the lines of a figure in relief and one which is not yet in relief appear to be of unequal size; the habit that was formed at the beginning of a detestable (?) education of giving every stroke of the charcoal a little nudge and giving the appearance of relief of a thing that turns is a great hindrance <u>to seeing</u> the form the form simply the outline; relief is a degradation in pictorial art and the artist must see only a degradation, not a thing that turns, the directness of the drawing and the gradations of color not the actual nature of the real object.

26 November 1890

March 91. The <u>work</u> must not depend on a passing impression; all we need understand is this: one emotion will produce one work, another will produce another; in other words for every work there will have to be a method, a particular type of composition; it seems that there need be nothing in common between two works. Think of the words that help us *oeuvre ouvrage* It used to be that a man's life went through a series of

S tudy for *Interior with Red Bed* and *The Suitor*, 1893.

ouvrages and the result formed <u>an oeuvre</u>. What is the difference between them; the *ouvrage* is a part, the oeuvre is the whole. The *oeuvre* has only one method, all of the actions put together. This method depends on <u>the spirit</u> of a harmonious development of the faculties thus all the *ouvrages* will have the same method.

March 1891

Forms <u>appear</u> before our eyes. We see them and they appear. In what conditions? A form stands out, in other words it exists separately from what surrounds it; it is lighter or darker than what is around it; it is more or less luminous; it is the feeling that the painter expresses of this more or this less, and depending on the degree of awareness on the one hand and sincerity on the other, the work will be.

2 April 1891

The Nabi period

The Nabi venture had a great deal to do with firm and lasting bonds of friendship. Frustrated by the mediocrity of the academic studios, the young artists approached their work with unusual intellectual rigor. For Maurice Denis, Pierre Bonnard, Paul Sérusier, Ker-Xavier Roussel and Edouard Vuillard, being a painter also meant reading philosophy, directing plays, and creating objets d'art.

The origins of the Nabis
The formation of the group, as recounted by Maurice Denis in an article on Symbolism...

The boldest of the young artists who around 1888 were attending the Académie Julian knew almost nothing about the great art movement known as Impressionism that had just revolutionized the art of painting. They had got as far as Roll and Dagnan; they admired Bastien-Lepage; they talked about Puvis with respectful indifference, suspecting in all conscience that he did not know how to draw. Thanks to Paul Sérusier, who at that time collected the contributions to expenses at the little studios on the Faubourg Saint-Denis—a job he performed in a brilliantly imaginative way—the environment was without a doubt much more cultivated than in most academies; we regularly talked about Péladan and Wagner, about the Lamoureux concerts and decadent literature, of which we knew little; a pupil of Ledrain's introduced us to Semitic literature, and Sérusier explained the doctrines of Plotinos and the School of

Alexandria to the young Maurice Denis who was preparing for the philosophy examination in the arts Baccalaureate.

It was after the summer holidays in 1888 that the name of Gauguin was revealed to us by Sérusier on his return from Pont-Aven. Not without an air of mystery, he showed us the lid of a cigar box on which we could vaguely make out a landscape formulated synthetically in violet, vermilion, Veronese green and other pure colors just as they came out of the tube with barely any white mixed in. "How do you see that tree?" said Gauguin, looking at a corner of the Bois d'Amour. "Is it very green? Then use green, the most beautiful green on your palette. And that shadow, is it more blue? Then don't be afraid to paint it as blue as possible."

That was how we were shown for the first time, in a paradoxical, unforgettable way, the fertile concept of the "flat surface covered with colors assembled in a certain order." That was also how we found out that every work of art was a transposition, a caricature, the impassioned equivalent of a sensory impression. It was the beginning of a

development in which H.-G. Ibels, P. Bonnard, Ranson and M. Denis took part right from the start. We began to go to places which were entirely unknown to our superviser Jules Lefebvre: the mezzanine of the Maison Goupil on Boulevard de Montmartre, where Van Gogh's brother showed us Gauguins from Martinique, and also paintings by Vincent Van Gogh, Monet and Degas; and Père Tanguy's shop in Rue Clauzel, where we were very excited to come upon Cézanne.

Maurice Denis, *Théories* (Theories) 1890–1910
"From Symbolism and Gauguin to a New Classical Order," Paris 1920

...and as it is related by Claude Roger-Marx

The Nabi group, as it was baptized by the poet Cazalis, came into being. It consisted of Sérusier, Ranson, Denis, Vuillard, Roussel, Ibels, the sculptor Lacombe, the musician Pierre Hermant, Lugné-Poe, Seguin, Percheron, René Piot, Verkade, Vallotton, and lastly Maillol. Although

these "intellectual firebrands", these "prophets", took life very seriously, no-one could accuse them of taking themselves seriously. There were plenty of childish antics in the midst of their passions. Think of the nicknames they gave each other: Sérusier was the Nabi *à la barbe rutilante* (with the bright red beard), Verkade was the obeliscal Nabi (because of his size), Bonnard was called *japonard*, and Vuillard was the *zouave*. Sérusier painted Roussel in a priestly garment which was completely fictitious. On their way home from the "Dîner de l'os à moelle" in the Passage Brady, or from Henri Lerolle's or Ranson's apartment, the conversations continued; they would run off to boo Meissonier under his windows. These evening pranks gave them a rest from excessive mental tension. "Rarely," said Paul Valéry about the Symbolists, "have more fervor, more boldness, more theoretical research, more knowledge, more pious attention, more disputes been devoted in so few years to the problem of pure beauty." And this was just as true of the Nabis as of their poet friends.

From right to left, Vallotton, Coolus, Vuillard and Ker-Xavier Roussel at Villeneuve-sur-Yonne in 1899, at the home of Misia and Thadée Natanson.

Lugné-Poe

Forty years on, the founder of the Théâtre de l'Œuvre recalled his relations with the Nabis.

We were four, like the Musketeers, at number 28 rue Pigalle: Maurice Denis, Edouard Vuillard, Pierre Bonnard and I. It was in that little studio, at the very top of a house on the corner of Rue La Bruyère, that the neo-traditionalists came into being, whom Arsène Alexandre was the first to single out, and it was there that Gustave Geoffroy came to see us. I had known him since my childhood, when my parents lived at 14 rue Martel, and he was then living in Belleville, not far away. I had shown him Denis's first sketches for *Sagesse* and Vuillard's studies of Félicia Mallet in *L'Enfant prodigue*. It was also from number 28 that I bore off to *Art et Critique* Denis's manifesto, which can fairly be called historic, on behalf of the neo-traditionalists.

Sérusier, Percheron, Gauguin, Coquelin-Cadet, Ibels, Ranson, Le Barc de Boutteville senior, Mauclair, and many others whose names escape me, sat round with us in that studio, which was no bigger than a pocket handkerchief. Its windows looked out on the rue Pigalle. Everyone did their work there; I, alas, never had anything visible to show for mine! Ah, the melancholy of white greasepaint..!
It was the birthplace, also, of the Nabis, those chaste prophets of painting who stood out like a new branch from the proud tree of Signac, Seurat and Pissarro.

Thanks to Denis I already had the pleasure of knowing not only Bonnard but also Edouard Vuillard. He was very different in character. Fastidious by nature, he was exempt from the fanaticism which underlay Denis's gentle ways. In Vuillard's company, life smiled and took on its most peaceful aspect. Nothing could have been more harmonious than Vuillard's way of life and his behavior in society. He was loving-kindness personified. Never the man to put himself forward, he effaced himself behind the merits of his three colleagues. He kept himself in the shadows before projecting his light, which was so very varied and came to him along with each of his white hairs.…

One evening when we had been invited to dinner by Marie Aubry, who had played Pelléas, we were trying to find a title for this theater; until then we didn't have one. Vuillard opened a book at random, and pointed at the word "l'Œuvre".

Lugné-Poe,
La Parade. Le Sot du Tremplin
Gallimard, Paris 1930

Bonnard and Vuillard

An abundant correspondence bears witness to fifty years of unfailing friendship.

13 April 1891
My dear Vuillard,
You can imagine the pleasure your letter gave me… I am preparing some work here which I shall be able to finish in Paris. I do not know how I am going to make something out of my musical theory book. I need to give myself inspiration by thinking of the missal painters of times gone by, or the Japanese who put art in encyclopedic dictionaries.

All best wishes and thank you for all your help.

P. Bonnard

I have done a little painting which is much too sensible, am I turning classical or going soft?

7 August 1892
Bonnard old chap,
…I am writing to you somewhat in haste. I have been to Aurier's, there was nothing. Received the Théâtre d'Art publication, in which they've made a fine mess of your drawing. The whole thing is very ugly, it's best not to think about it… My work has been rather neglected, but now that I am back in form and all alone in Paris I hope things will get going again…

Bonnard replies:

16 August 1892
…I am happy to see that although you have moments of idleness you also have moments of inspiration and work. I think that will come for me too. I have not lost all hope of understanding something about oil painting…

In this letter, Bonnard alludes to the six panels commissioned by Paul Desmarais:

19 September 1892
My dear Vuillard,
Although I have withdrawn from the world, the news you send me of it does not leave me indifferent, I would go so far as to say that it gives me great pleasure to receive it, so don't trouble yourself with any fear of boring me.

I am pleased to hear that your overmantels are nearly finished and that you have enjoyed working on them, which reassures me as to the end result, since I believe that you are incapable of "fouling things up", as so often happens to me.

The good news from my side is that I do in fact feel less likely to make those terrible blunders, because I have consolidated my ideas on many of the points we talked about this winter, the result of which has been to make me more independent, which I can see I very much needed to be.

Oil painting among other things has taken up a lot of my time, it's going very slowly and timidly but I think I am on the right track.

P. Bonnard

21 November 1892
…I am very glad to hear that you as well as Roussel are out of the doldrums, your previous letter had worried me… I am not really in a position to give you advice, especially since I myself am slightly in the doldrums, which is perhaps not entirely unconnected with your absence. I cannot stand living the life of the selfless artist when I am all alone in Paris. I need to discuss things with real brothers like you. I have seen Rasetti a few times recently and that is when I have enjoyed myself most. He's a true believer…

I think one of Roussel's pastels has been sold, or almost, it's the landscape; it's getting a very good reception. I have a vague idea that the buyer is Roger Marx.

Despite everyone's solidarity over this little panel, what an annoying place that Boutteville shop is. But I

don't want to annoy you, maybe if I'd sold a painting I would find it less annoying...

 P. Bonnard

Like his friend, Bonnard senses the particular combination of secrecy and transparency that is predominant in Mallarmé's poetry.

17 September 1895
My dear Vuillard,
Thank you for sending the litho pen and paper, but I am so idle that I haven't used it yet. I saw two of your drawings in the *Revue blanche*; the one for the Œuvre album reminded me of Mallarmé because at first sight it seems obscure, and then when it becomes clearer you can see the great purity of its construction. I mention this to you even if you didn't attach any importance to your drawing, because it has had a lot to do with my desire to work in black and white...
All best wishes,

 P. Bonnard

Thadée Natanson

The editor of the Revue blanche *and husband of Misia was also one of the first collectors of Vuillard's paintings.*

For the first time..., we have something like a complete exhibition of M. Vuillard's works, and can see what profound admiration they deserve.

Apart from *The Garden, Fenêtre effet de soir* (*Window in the Evening*), and that extraordinary young woman in a blue dress with her arms outstretched who lingers so disturbingly in the memory, it is above all the portrayal of interiors that has enabled the artist's inspiration to develop.

His intentions are much more difficult to discern, and although he must no doubt have engaged in profound reflection before venturing to allow himself to be carried along so freely by his temperament and to fix on such felicitous expressions of his emotion, what does become clear at least is not a desire on his part to charm or to make his works conform strictly to a theory, but simply the depth of flowing grace in the paintings, and the attraction of the particular intensity of their tonalities and colors.

Perhaps those whose emotions are aroused by scenes of private life will find that the immediate appeal of M. Vuillard's paintings lies in the subjects in which he delights; to appreciate his work fully, however, one must be capable of experiencing the great joy that is to be gained from pure color.

Is it because one is transported by such a deep sense of being enveloped in charm, and by the unqualified admiration already professed for the intensity of these colorings, that one is unable to give a clear definition of one's feelings? Yet however often and however much one would like to speak of their appeal, it remains hard to find the words to explain all the inexpressible joy they offer.

 Thadée Natanson
 "Exhibitions.—A Group of Painters"
 La Revue blanche, November 1893

The critics

In 1896 the critic Gustave Geoffroy commented on the paintings of Vuillard and Bonnard, when for the first time

they were exhibited alongside some Impressionists at the Durand-Ruel gallery.

There is a clear resemblance between the two artists in their way of presenting a scene, and I also see great differences; Vuillard is a franker, more daring colorist with his brilliant bursts of blue, red and golden yellow, and at the same time one senses that he has a melancholy spirit and a serious mind. Bonnard on the other hand is a gray painter who delights in subtle shades of purple, reddish-brown and other dark colors; and yet in every brushstroke there is a mischievous observation and a playful gaiety which have great charm and refinement.

The Belgian poet Emile Verhaeren showed unconcealed admiration for Vuillard's virtuoso technique.

How can I describe the delicate grays with pinks, greens and yellows breaking out of them! Only in certain fabrics and carpets will you find such rare harmonies. The effect is of an exotic beauty which has been successfully acclimatized. The brushstrokes proceed in little touches. Sometimes it looks like the work of bees, or better still swallows making their nests. All these touches stick together to form a mass. The process is odd and unexpected; the results that it produces in M. Vuillard's work are decisive.

Emile Verhaeren
"Les Salons"
Mercure de France,
June 1901

The break-up of the group

In his journal entry of March 1899, Maurice Denis draws the conclusion that the painters are drifting apart.

At our exhibition at the Durand-Ruel gallery I noticed certain features which differentiate our paintings.

Group I: Vuillard, Bonnard, Vallotton: 1. Small paintings. 2. Dark. 3. Painted from life. 4. Painted from memory, without models. 5. Little importance given to the figures, and therefore to the drawing. 6. Will look better in a small, dimly-lit apartment than in a studio or an exhibition. 7. Complicated subject matter— Semitic taste. All of this applies to Valtat also (apart from features 2 and 5).

Group II: Sérusier, myself, Ranson: 1. Large paintings. 2. Painted with some pure colors, some darker than others. 3. Symbolic. 4. Use of some documents, geometric measures or models. 5. Great importance of the human figure. 6. Had to be painted in studios. 7. Very simple, uniform subject matter—Latin taste.—Article by Geoffroy who praises another feature of the first group. 8. Modern subjects.

Maurice Denis
Journal, Vol. 1 (1884–1904), Paris, 1957

On the occasion of that same exhibition at the Durand-Ruel gallery in March 1899, critic André Fontainas lamented that Denis's group (the Nabis) had no pervasive style or technique.

"In front of these one doesn't understand the tie that unites them, unless it is a serious friendship."

André Fontainas, "Art Moderne"
Mercure de France, 1899

The Consecration

There was no sudden change in Vuillard's style after 1900, but rather a confirmation and fulfillment of certain tendencies. He joined the Bernheim-Jeune gallery and became a sought-after portraitist, which enabled him to make a comfortable living. He remained close friends with the former Nabis, but his circle now also included personalities from fashionable Parisian society, the arts, literature, the world of finance, and the cinema.

Fidelity: Maurice Denis

Toward the end of his life Maurice Denis felt that he was much closer to Vuillard than he had imagined. They often traveled together, for instance to England in 1932.

Have I told you how much satisfaction it gave me to see your works at the Gangnat sale, in the middle of the Renoirs? As I told Bonnard when I met him at the exhibition, what was new for me was the contrast of an art that is both as sensitive as Renoir's and infinitely more self-willed, or to be precise more intellectual. I had never realized just how full of spirituality your works would seem after all these years; that if they had more plastic qualities they would be more similar to mine for example (I say this without any self-conceit) than to the Impressionists, and that in that and many other respects there were in fact much closer and deeper links between us than I imagined. The only one who was deeply in tune with you was Cézanne, in paintings like *Bouquet* and *The Bank of the Oise.* Compared with you and Cézanne, Renoir was just an amiable dauber, one of genius of course, but even so too uninterested in thought, which is the most important thing about a man. You experienced the pleasure of thinking for its own sake, with the same restless intelligence that you see in the great works of the past and which, since we shared it, brings us closer to you. I make that judgment very objectively, without any bias or ulterior motive. It hit me straight in the eye and in the mind. What you have given me in this way is a real joy, and a consolation for growing old. [1925]

Maurice Denis
Journal, Vol. 3 (1921–43), Paris, 1957

The secrets of the portraitist

Vuillard was one of the most famous portraitists of the inter-war years. Bankers, actresses, and aristocrats clamored for his services.

Vuillard frequently painted his portraits in really difficult conditions. One evening we went to pick him up at Place Vintimille, and as we were going together down the Boulevard des

Batignolles on the way to the Rue de Naples, he told us about the portrait of Jane Renouardt which he was in the middle of painting at her property in Saint-Cloud. The actress had asked to be painted in an evening gown, so he started the work by lamplight in the drawing-room. At the second sitting she suggested to Vuillard that they go into her bathroom where it was warmer. Vuillard agreed and started his painting again. Jane Renouardt settled down in front of her three-paneled mirror and Vuillard sat on a stool, in a corner of the room that was hemmed in by the bath. The next day he felt so awkward in the cramped space that he decided to sit on the edge of the bath itself, which was obviously still quite uncomfortable. "Today," he declared with a laugh, "I got right into the swim, and after that I felt fine."

Jacques Salomon, *Vuillard*, 1945

Official commissions

On 5 August 1936 the curator of the Petit-Palais sent Vuillard an official commission which gave Vuillard the opportunity to get together again with his friends from the Nabi period, and paint the portraits which have become known as "The Four Anabaptists."

My dear Master,
Following our last conversation, I would like to inform you without further delay that the City of Paris commission for the distribution of special honors to artists on the occasion of the 1937 Exhibition has decided, at my suggestion, to commission from you, for the price of eighty thousand francs, the four panels representing: Aristide Maillol, Pierre Bonnard, K. X. Roussel, Maurice Denis.

Vuillard and Yvonne Printemps in 1934.

With regard to your very charming sketches, as I have already said, a special ruling of the City of Paris stipulates that they must be shown in addition to the commissioned decorations. In these circumstances, and bearing in mind your misgivings, I have spoken about this matter to our friend Henraux. He tells me that he will be glad to hand these sketches over to the Musée de la Ville de Paris.

I very much hope, my dear Sir, that you will be so good as to confirm our agreement. Assuring you of my affectionate admiration,

Raymond Escholier

In 1937 Vuillard, along with Bonnard and Roussel, received his first state commission, for the decoration of the foyer of the new Théâtre de Chaillot.

When the matter of the decorations for the Théâtre de Chaillot was being discussed, Vuillard was worried about the way in which the commissions had been distributed; we recall hearing him declare: "It will be the Tower of Babel!"

Without wishing to discuss the talents of each individual, he would have liked it if instead of the tasks being parceled out, there had been an overall plan or at least close consultation between the designated artists. He was concerned that there should be a unity between the three panels which were to be placed above the entrance doors of the auditorium, the painting of which was to be shared between himself, K.-X. Roussel and Bonnard, and so he waited until the other two had finalized the outlines of their paintings before deciding on his own, to ensure that the whole decoration had the desirable harmony.

When the finished panels were mounted, Vuillard went one morning to the Palais de Chaillot, and after leaving the theater came for lunch with us. We had seen him working on his decoration in a cramped room in his apartment on Place Vintimille, where the canvas took up the whole of one wall, and we had frequently heard him complain that he couldn't stand back far enough to judge the effect. We were therefore looking forward to hearing his impression of the work now that it was in place. He did have reservations about certain details, which he subsequently altered, but on the whole he was satisfied. Roussel in his usual way had completely changed his decoration several times in the course of painting it, and in the end Vuillard had let him have the central position which had originally been assigned to him, in order to accommodate the monumental work that his friend's painting had now become. Roussel had been pressed for time, and had had to deliver his work before it was finished, but Vuillard thought that his painting had a grand style. "What about Bonnard's panel?" we asked. Vuillard

declared that it was ravishing, but when we pressed him to tell us what its subject was, he put his head in his hands and eventually told us that he had no idea, adding however that it was a charming bouquet of colors.

Jacques Salomon, *Vuillard*, 1945

Vuillard at the Institut de France

The artist who had not wanted to study at the Villa Médicis was now commissioned to give his opinion of this institution.

I know too well how important, how appealing and how vital our contemporary French school is to be surprised that these young people's minds are more or less exclusively concerned with it. Nevertheless I am anxious to tell

L a Paix protectrice des muses (*Peace, the Protector of the Muses*).

them that the love and admiration they feel for it are not incompatible with the study of those extraordinary works of art among which they have the opportunity to live for a while. I know that they may find them disconcertingly different from what they are used to, and far removed from their current preoccupations. Even so it would be an excellent thing if the novelty of this experience had some influence on their work, because it would prove that they have taken an interest and show that they have derived some advantage from their lives as students in Rome other than a period of financial security.

May I add, and this will perhaps have some value in their eyes (coming from someone older who studied in complete freedom, that is to say in a completely random way) that the greatest, the most independent of the modern innovators, without even going back too far, from Puvis de Chavannes to Manet, from Degas to Renoir and Cézanne, all worshiped the Italian masters, studied them profitably, took nourishment from them, each in his own way, not with a view to empty, superficial imitation, but in a practical sense, trying only to penetrate their living qualities and appreciate the methods behind their astonishing achievements.

Report to the Institut de France on student visits to the Académie de France in Rome (1938), quoted by Jacques Salomon, *Vuillard*, 1945

The retrospective in the Pavillon de Marsan in 1938

Organized by his friends Romain Coolus and Waldemar George, this large retrospective made it possible to take stock of Vuillard's work.

His private interiors and portraits already had decorative themes, that is to say that essentially, as an artist who was conscious of the *raison d'être* of his art, he always limited himself to showing those aspects of the objects and people he painted that were necessary for a painter, in other words their pictorial resonances. A human being would always be summed up for him in a few sonorities of color, the symphonic interest of which would be created by the whole array of other colorful features in the world. Everything that is has an aesthetic significance, and it is the painter's task to discover and then hold on to it. In friezes and panels of astonishing variety and sumptuous content, he brought the greatest spectacles of the world into the private arena, and by imposing on human beings the humility of being, like all the other objects in the world, no more than decorative themes intended to belie the monotony of everyday life, he left on the walls of certain homes a meditation in color, in which ideas and sense impressions are blended together with the greatest subtlety.

Romain Coolus, "Edouard Vuillard", *L'Art vivant*, May 1938

Last letters

April 1940
My dear Vuillard,
It is a long time since I last heard from you. I trust that you have weathered this very harsh late winter... The days go by too fast— working in the morning and going down to Cannes in the afternoon, that is essentially what I am doing. I am very interested in the landscape

and my walks are filled with reflections on the subject. I am beginning to understand this part of the country.... I saw Gaston Bernheim several times while he was at the coast, and on one occasion I met Matisse and an old painter called Adler who knew us well at the Julian studio.... I think of you often and send you all best wishes.

P. Bonnard

Vuillard sent his last letter to Bonnard on 4 May 1940. He died on 21 June in La Baule.

4 May 1940
My dear Bonnard,
If I wrote to you every time I think about you, our past, painting, etc. you would have enough letters to fill a library. But in a word, what can I tell you? other than news about health: mine is better, I have started working again, the results are not wonderful but I often find it interesting. I believe that you recently saw me in a moment of disarray and not much modesty. I am more or less recovered now; the late spring has finally come. Roussel caught the flu and had to stay upstairs in bed for two weeks. He hasn't yet got back to the work he went back to Paris to do. What about you, do you think you will have the opportunity or the need to come over here? I would be very pleased to hear from you at this rather difficult time.
Best wishes, Yours ever,

E. Vuillard

Post mortem

The dramatist Jean Giraudoux, whose portrait Vuillard had painted, paid homage to the deceased painter.

And so why should I not accept, today as I travel across the plateaux of the Velay and the Ardèche, the gift that Vuillard has suddenly bequeathed to me, the gift of suddenly seeing humans and landscapes with my own eyes? Everything along these roads bordering the mountains speaks of Vuillard. Everything is ordered by him, the poppies are in the same field, apart from one which is in among the oats, the cornflowers are all in another, except for one clump among the barley. Everything that is Vuillard shines out from every being and every object: the yellow ribbon, the first yellow after his death, sits brightly in the little girl's hair, the pink tongue in the dog's mouth. And it is not just that these half-wild, unspoiled parts of the country by nature possess the color and finish of our gentlest painter, it is also that since Vuillard is dead, nature now finally agrees to be seen by everyone as it was seen by him, takes delight in paying homage to Vuillard dead and Vuillard brought back to life by giving to all what was due to Vuillard alone, and makes the whole of France his pastel and his crown.

La Chaise-Dieu, 1940
Jean Giraudoux
Littérature, Gallimard, 1967

Maurice Denis learned of Vuillard's death on 15 July 1940 through a telephone call from Roussel. In February 1941 he noted with feeling in his journal:

February. Vuillard loved the environment in which he lived for the sights that his memory retained from day to day and for their unexpectedness and bite, which he conveyed in so many and such various ways in the paintings that came from his studio. Nature on its own

did not provide him with such a heady stimulant. He needed those theaters, those restaurants, those salons and that lighting to feed his memory and satisfy his curiosity. With regard to sense impressions he became more and more demanding to the point where he went in search of the bizarre, from which he drew surprising techniques of composition and coloration, which usually led to what we might call a new beauty.

Maurice Denis, *Journal*, Vol. 3

The painter André Lhote gave a more lukewarm assessment:

Amid the fracas of France's collapse, Vuillard's death did not make much of an impact. He died as a charming, peaceful old man, just the opposite of what Paul Cézanne was before his even more silent death. All his life Cézanne was wracked by anxieties which in his old age bordered on drama; Vuillard, on the other hand, spent his whole life as a distinguished connoisseur, savoring the delights of an opulent bourgeois existence, which he recorded as we know on subtle canvases on which, with the greatest possible caution, he laid down the quintessential elements that make up the stuff of a painting. His tonalities, apparently worn out from over-refinement, had a delicious appeal thanks to skillful composition, although there were genuine moments of violence, the vermilion of a flower, the pure blue of a patch of summer sky, the orange stripes on a chaise longue, which awoke the symphony and gave the whole painting a feeling of plenitude. Many masterpieces have resulted from this aesthetic, which is distantly related to that of certain 17th-century Flemish painters who use paneling, furniture, cornices,

doors, windows, all the immobile elements of architecture, as a framework for the slow unfolding of the least ostentatious acts of family life. It was to the life of interiors, if not the inner life, that Vuillard devoted a particularly large amount of his artistic activity. Nevertheless in 1937, for the Exhibition theater, he painted a large landscape that was both magical and real, and so beautiful that no one thought to regret that it was not decorative in the true sense of the word. In his old age, alas, there were no more such achievements; ill-prepared for the sacrifices that the art of the portrait demands, he could not resist the absurd temptations that were offered by the face of a wealthy socialite or a parvenu, and above all by the sacrilegious demands of the bourgeois who "poses". With regard to this, the portrait of Mme de Noailles, surrounded by flowers and drapes, and viewed by too many of our contemporaries as a masterpiece, is in reality nothing but an insult by the artist himself to his own work. The vulgarity of the colors, the overloading with brushstrokes, the piling up of facial details, the glaring realism of the roses and fabrics, represent the triumph of that bad taste which we all look out for anxiously so that we can stamp out such fits of insanity.

It may have been this portrait that earned Vuillard his admission to the Institut de France. If so, it was because the France of yesterday, a France that had died from laziness and pusillanimity, seemed to be waiting for a man of talent to slip to the depths of decadence before elevating him to the highest honors. [1941]

André Lhote
La Peinture libérée
Grasset, Paris, 1956

The biographers

After 1945 the figures in the forefront of the artistic scene were Picasso, Manessier, and Matisse. The middle-class world that Vuillard showed in his paintings was, consciously or otherwise, identified with France's defeat, and his virtuosity was regarded as a negative quality. It was in the course of this critical eclipse that two of those who had been close to Vuillard wrote biographies of him which reconstructed the whole body of work he had done throughout his life.

Jacques Salomon

The memories recounted by Jacques Salomon, the husband of Vuillard's niece Annette Roussel, are an invaluable mine of information about the life of the painter.

He spent most of the money he earned on good deeds to those around him, anticipating misfortunes and helping all those who appealed to his generosity. The sight of misery was unbearable to him. Yet we never heard him complain about his difficult youth; on the contrary he declared that necessity had been the mother of invention and that he owed everything to it. However he also knew what help in time of need could do to mitigate distress, and that was his constant preoccupation.

His essential quality was goodness. There was never the slightest note of sourness in what he said, which was always full of indulgence and understanding. ...

The truth is that although he was not a practicing Christian, Vuillard had retained the stamp of the Christian education he had had with the Marist Brothers, and his character was naturally and deeply religious. He was continually beset by scruples, and kept silence for fear of speaking out thoughtlessly on whatever subject was suggested to him. One day we declared that he was a saint, and he replied with a smile: "Most certainly, since saints are the most appallingly tormented of beings!"

In the last twenty years of his life we often saw him engrossed in Sainte-Beuve's *History of Port-Royal*, or *The Life of Rancé*, and right at the end in "The Literary History of Religious Feeling in France" by Abbé Bremond, because he was deeply interested in the lives of these great religious and meditative men who were consumed by divine love. *The Imitation of Jesus Christ* was his bedside book.

He was not a great concert-goer, but he had such a deep love of classical music that we often saw him with his face bathed in tears as he listened to some of the great symphonies—Beethoven, Bach, and above all Mozart were his favorite composers.

The first impression of Vuillard

T he artist, Rue de Calais.

physically was that he was rather petit bourgeois. His clothes were very proper and uncolorful: a dark suit and lavallière tie which was hidden by his beard, which had become very white over the years. He would wait until his suit was virtually threadbare before ordering a new one, preferably at the Belle-Jardinière whose Place Clichy branch was very close to his home. In short he was not the least concerned about elegance. When he greeted people, although in general he was friendly and smiling, he usually went no further than to shake their hand, reserving a deep store of affection for his family and close friends. He had a rather serious, delightful voice which lent itself to infinite, subtle varieties of tone.

The slightly sad, serious look in his eyes was pierced by a singular energy. When he spoke, a mouth as red as a cherry appeared under his thick moustache, revealing very white teeth when he laughed. He loved the world, which offered itself to him as a relaxation, but even so he made little effort except in the company of pretty women or men of wit, and consistently held back from general conversations. He never talked about his own work, or about his future projects, but he liked to talk at length about Bonnard's painting and the remarkable organization of Maurice Denis's work, while reserving first place for Roussel, whose poetic feeling he deeply admired.

On the other hand, he really had to be provoked before expressing his opinion of certain living painters.

He held the fake and the slipshod in equal contempt. He detested the "casual" approach, and abstract experiments left him completely indifferent. He did go to the exhibitions, however, taking an interest in the "young folk"; but he was careful not to make polite compliments, and his judgements were always very measured....

He never spoke without deep emotion of Rembrandt, whom he called "the giant". One day we stopped together in front of *The Carpenter's Family*, and he explained this moving interior scene in detail, then suddenly laughed and said: "He didn't paint anyone but Jews either!"

Jacques Salomon, *Vuillard*, 1945

Claude Roger-Marx

Claude Roger-Marx, a collector and friend of the artist, wrote a book on him which even today remains one of the most discerning analyses of Vuillard's work.

Coming from a strict, middle-class background which left him with the daily habit of examining his conscience, a Jansenist outlook, and a propensity for meditation and solitude, he seems to have been forced (as he sometimes put it himself) to act like a Jesuit, since instead of fleeing the world and rejecting painting as just another vain pursuit, he

had to compromise with the passions and the century, to love sensuous pleasure and make others love it.

… If, as André Gide said, "the qualities that we like to call classical are above all moral qualities", if classicism is "a kind of harmonious bundle of virtues the first of which is modesty", perhaps Vuillard never came closer to the great traditions. Because he had kept his wonderful memory, because his hands had never obeyed him more faithfully, because he had never been so skillful (in the grand sense of the word), we saw him resolving countless problems with the patience of an ascetic. As he painted things he almost forbade himself to intervene in their arrangement. He kept in the background, accepting everything as a passive observer whom nothing could deter.

The deformations, peculiarities and even the silences that had once enchanted us he now avoided as if they were formulaic. To simplify the register of color, to avoid contrasts or dissonance, seemed to him to be a concession, an inexcusable impoverishment considering the variety and infinite complexity of the plastic elements available. This was the reverse of the development that Manet, Monet, Degas and Van Gogh underwent; they started with a more or less literal reproduction of what they saw, then moved toward an ever broader synthesis. In Vuillard's case, no doubt it was because when he was very young he practiced what might be called the disciplines of freedom that in later life he aspired to ones that were more authoritarian. He reacted against certain discoveries that had been made by his generation, and subsequently vulgarized, with the same vigor that he had shown in fighting against an opposing set of

conventions forty years earlier. It was this that enabled those in official circles to believe for a while that he was taking a step in their direction, that he repented the daring innovations of his youth; in short, that the revolutionary had crossed over to the conservative benches. A number of critics made the same mistake, especially after he became a member of the Academy. He did this in fact in the hope of giving back to a much disparaged institution its original greatness and sense of mission.

Claude Roger-Marx
Vuillard et son temps, Paris, 1945

André Chastel

The first important book by the great Italian Renaissance specialist was an extremely original and penetrating analysis of the Nabi painter's works.

Every epithet dear to the Symbolists—like Mallarmé, like Verlaine, musical, Wagnerian even—has been used to describe Vuillard's intimism. There is some truth in all of them. No one responded as deliciously as he did to a certain demand for refinement at that time. Those tiny, dense paintings leap out at the viewer because of the charm of their tonalities; they make an impact through the effect, whether abrupt or harmonious, that they have on the senses before they have even been understood. Yet this type of art would be in danger of remaining the almost incommunicable property of the older people who loved it, had it not taken on a decorative form which remains effective and true. Of this period which is fading into the past in so many respects, Vuillard, like Debussy, is one witness who deserves to survive, among many others who do not. He owes this in particular to the as yet too

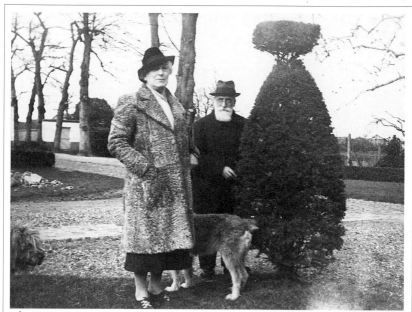

An old couple: Vuillard giving Lucy Hessel a sidelong look at the Château des Clayes (c. 1935).

little known large paintings with which he decorated Parisian apartments.

André Chastel, *Vuillard*, Paris, 1946

"Vuillard and his Kodak"

Jacques Salomon and Annette Vaillant, the daughter of the actress Marthe Melot and Alfred Natanson, were the first to emphasize the importance of photography in Vuillard's creative process.

Although the personality of the photographer asserts itself in the choice and angle of the shot, as is the case with Degas as well as Vuillard, the camera cannot claim to do any more than record what is there in front of it… and that is where it meets its limits. One morning I was telling Vuillard about a conversation about color photography I had had recently with Bonnard, who was amazed and even somewhat disturbed by some of the results it had produced. Vuillard, who knew how his friend loved to be paradoxical, replied without putting down his paintbrush that painting would always have the advantage over photography since it was done by hand. Although at the time I was disappointed to receive such a simple answer, I still feel now that it was extremely discerning. By copying living nature, Vuillard imposed on what he looked at a rhythm that was him, that was the mystery of his whole personality. The movement of his hand communicated it to the canvas… and left its signature on it.

Jacques Salomon and Annette Vaillant
"Vuillard and his Kodak"
in *L'Oeil*, April 1963

Modern criticism

André Chastel had set the tone for a new approach to Vuillard's art. Exhibitions of his work or that of the Nabi group (Franco Russoli's in Milan in 1959, John Russell's in 1971–72) made it possible to reassess the artist's place in the modern tradition. A few recent examples are offered here of his critical return to favor.

I cannot resist it; every time I go back to the Petit Palais to see Vuillard's *Bibliothèques* (*Libraries*), I think of Proust. I am struck, as I always have been, by the minimal difference in density and relief that separates the characters in his book from the teeming, living mass that is the book itself, and from which they only just emerge. They are like barely projecting bas-reliefs, caught in the substance of the book and barely standing out: not from a smooth surface, but from one which is already swarming with life, like the walls of Hindu temples. Sometimes it even seems as if these characters come into being almost without solution of continuity, simply because of an excess of density in the matter of the book.

Julien Gracq
En lisant en écrivant
(Reading and Writing)
Paris, 1981

On the subject of the links between Vuillard and photography:

As I was exploring what is perhaps the most pictorial aspect of Vuillard's art—the crafting of textures—I began to think of photography; Vuillard's canvases, especially in the early part of his work up to 1905, combine decorative motifs and figures in an interplay of themes and variations which embrace and put life into the whole surface of the picture; the background elements detach themselves and come up to the foreground of the surface; the figures seem to be swallowed up by the textures, or else to be moving forward in a trembling, condensed form. Looking at certain Vuillard canvases where the figures are fused with the background, and seemingly absorbed by it, one is reminded of the "image in the rug" which obsesses one of George Perec's characters in *La Disparition* (*The Disappearance*): "As he became more and more absorbed in examining his rug, he suddenly saw five, six, twenty, twenty-six combinations appear, fascinating but weightless rough drafts,…a whole lot of imperfect sketches, each one of which appeared to be contributing to weaving, to constructing the layout of an initial sketch that it was simulating, tracing, getting close to but still not revealing…"

One might think also of the portrait of Claude Bernheim (1906) in the Musée d'Orsay, which alternately shows us the little boy in a white satin suit against the blurred background of an Aubusson tapestry riddled with green and brown holes, or a hazy

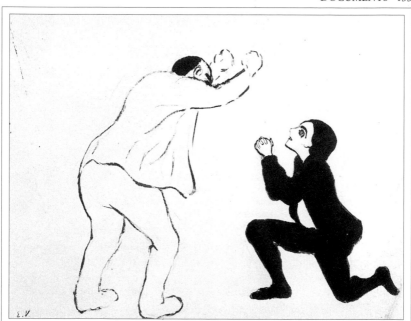

$\Sigma.V$

The elder Pierrot berating his son, Pierrot, in *The Prodigal Son* (1890)

outline that acts as a screen, masking a shepherd boy and girl "and their blue dog" in a Roussel-style Arcadia. There is also the later portrait of his mother in front of a window (1914). In profile, Mme Vuillard blends in with the landscape; in "floating vision" her features dissolve or come back together. "The positive and negative motifs— backgrounds or figures—are inextricably linked, fused and… reversible."

Emilie Daniel
"L'Objectif et le subjectif: Vuillard photographe" ("The objective and the subjective: Vuillard the photographer")
Les Cahiers du Musée national d'art moderne
Paris, spring 1988

The connections between Vuillard and the neo-classical tendency:

In 1901, assessing the talents Denis demonstrated in his religious decorations at the chapel of Le Vésinet, Vuillard noted how his friend excelled at giving a solid support to fragile charm, a precision of forms to imprecise sentiments. Vuillard could not share Denis's love of classicism, which was increasingly visible in the clarity of his forms and the frieze-like symmetry of his compositions. Nor could he see how Denis's new hero Cézanne could be understood in classical terms, reasonably enough pointing out Cézanne's kinship with Veronese, and thus with the

Baroque colorist tradition; and he had only half-heartedly espoused the Nabis's fervent admiration for Gauguin, whom he considered something of a "pedant."

This polarization in the idea of Vuillard and Denis, in a sense between genre painting and classicism, prefigured a crucial debate in the development of French painting between the turn of the century and the First World War and even beyond. Both Maurice Denis and Paul Signac were artists whose aesthetic ideas proved to have a strong influence on the new generation; the return to classical values manifested itself in the work of artists as diverse as Cross, Maillol, and Roussel, and significantly, the rising stars of Fauvism, Matisse and Derain, all of whom experimented with idyllic, arcadian themes and felt the timeless lure of the Mediterranean as the cradle of ancient civilization. One might argue that the careers of Matisse, Bonnard, and even Picasso can be characterized by their efforts to find a balance between those two extremes. Against this background, despite frequent periods of self-doubt, Vuillard remained committed to genre subjects taken from the modern everyday world and to an unsystematic technique based on sensation. His practical example was undoubtedly followed by younger artists—intermediaries between the Nabis and the Fauves such as Louis Valtat and Albert André— but he was never an artist who sought to attract pupils or disseminate ideas.

Belinda Thompson, *Vuillard*, Phaidon Press Ltd., Oxford, 1988

The significance of Vuillard's commissioned decorative paintings:

…Vuillard never stopped questioning the conventional precepts for the scale,

Coquelin-Cadet as Molière's Scapin (1890).

technique and subject appropriate to modern decoration.…

To twentieth-century eyes, which could not have seen Vuillard's paintings in the interiors…it is not the ensemble but the internal workings of the individual paintings—seen in these large-scale canvases in which space is flattened by complex, nuanced color fields and abstracted forms—that render them intelligible as *décorations*. They are not only decorative but they communicate through color, anticipating in many ways the quiet and evocative surfaces of Monet's late murals of the waterlilies, and, later, the

canvases of the color-field painters. Like Rothko, who explained that he used monumental canvases because he wanted his painting to be "intimate and human," Vuillard created mural-size *décorations* of relatively mundane subjects—city streets and parks, seamstresses, women in interiors, and bourgeois leisure indoors and out-of-doors to express a much more complex and ambitious concern for the possibilities of the painted surface as both backdrop and prime object for a specific urban dweller.

It was the relationship and collaboration, in varying degrees, depending on the commissioner—whether close friends like the Natansons or clients like Henry Bernstein—that made these projects possible. All were intended for a distinct personality and setting. The success of these works outside those settings attests to Vuillard's ability to adapt but not subordinate his art to what he understood about that location. It was the subsequent physical changes in these spaces, the moves from one apartment to another, and the consequent weakening of the ties— in many cases between the family-like relationships that for Vuillard were all important—that eventually led to the dispersal of the panels from their original settings, and…from their intended meanings.

Gloria Groom, *Edouard Vuillard, Painter-Decorator*, Yale University Press, London, 1993

The work of memory:

In general, Symbolist painting and literature placed more emphasis on the oblique expression of subjective states than on naturalistic description of the physical environment. In formulating this aesthetic, the Nabis were particularly influenced by the poetic theory of Mallarmé, the instigator of the Symbolist movement, and by the ideas of the philosopher Bergson concerning the power of the memory to transform. In a painting such as *Woman at the Closet*, the overlapping shapes, the figure—no doubt Mme Vuillard—seen in semi-darkness, the blurred frames and windows of the hinged door in the foreground, are all in keeping with Bergson's idea that reality has no fixed perspective, since the consciousness is fluid and defined by emotional states. Like simultaneously overheard fragments of conversation, Vuillard's paintings suggest the accidental, shifting nature of our perception of the world around us. The effect of this is to arouse a subjective reaction in the viewer, inviting us to share with the artist the feeling of a familiar moment relived in painting. Similarly, in a work such as *Two Women under the Lamp*, the objects in the interior scene are woven into the background, creating a series of surprising screens of wallpaper, fabric, furniture and figures which are far removed from realistic experience but very much akin to our experience of subjective vision. With Vuillard, the shifting nature of perception which had already been explored by the Impressionists takes on a stronger personal meaning thanks to the power of memory, which enables him to enrich his perception of the present with associations taken from the past.

Ann Dumas
"A la Recherche de Vuillard"
("In Search of Vuillard")
Catalogue of the *Vuillard* exhibition,
Lyons-Barcelona-Nantes, 1990

Further Reading

Chastel, A. *Vuillard 1868–1940*, 1946.

Dumas, A. and Cogeval, G. *Vuillard*, Lyons, Barcelona, and Nantes, 1990–91. Exh. cat.

Easton, E. *The Intimate Interiors of Edouard Vuillard*, Houston, Washington, and New York. Exh. cat.

Georgel, P. *Vuillard-Roussels*, Orangerie, Paris, 1968. Exh. cat.

Groom, G. *Edouard Vuillard, Painter-Decorator*, 1993.

Groom, G. *Beyond the Easel: Decorative Paintings by Bonnard, Vuillard, Denis and Roussel*, Chicago, 2001. Exh. cat.

Lugné-Poe, A. *La Parade* (I and II), 1930–31.

Makarius, M. *Vuillard*, 1989.

Mauner, G. *The Nabis*, 1978.

Monery, J. and Zutter, J. *Edouard Vuillard: La Porte entrebâillée*, Saint-Tropez, Lausanne, 2000. Exh. cat.

Perruchi-Petri, U. and Frèches, C. *Les Nabis*, Zürich and Paris, 1993. Exh. cat.

Preston, S. *Vuillard*, 1971, repr. 1985.

Roger-Marx, *Vuillard, His Life and Work*, 1946.

Russell, J. *Vuillard*, Toronto, Chicago, and San Francisco, 1971–72. Exh. cat.

Salomon, J. *Vuillard-Témoignage*, 1945; *Vuillard*, 1968.

Terrasse, A. and Frèches, C. *The Nabis*, 1990.

Thomson, B. *Vuillard*, 1988.

Thomson, B. *Vuillard*, Glasgow, Sheffield, and Amsterdam, 1991. Exh. cat.

List of Illustrations

Red, oil on wood, c. 1891–93, private collection.
26br *The Lilacs*, oil on cardboard, 35 x 28 cm, c. 1890, private collection.
27 *Little Girls Walking*, oil on canvas, 81.2 x 65 cm, 1891, private collection.
28–29 *The Seamstresses Folding Screen: The Seamstress, The Fitting, The Little Hands, The Lost Bobbin*, distemper on linen glued on canvas, four panels 95 x 38 cm, 120 x 38 cm, 120 x 38 cm, 95 x 38 cm, 1892, private collection.
30–31a Details of six decorative panels for Paul Desmarais: *The Dressmaker's Shop I, The Shuttlecock Game*, oil on canvas, both 48.5 x 117 cm, 1892, private collection, Paris.
30–31b *In Bed*, oil on canvas, 73 x 92.5 cm, 1891, Musée d'Orsay, Paris.
32 *Women in the Garden*, oil on canvas, 74 x 54 cm, 1891–2, private collection.
33 Program for *Monsieur Bute* at the Théâtre Libre, lithograph, 1890, Bibliothèque Nationale, Paris.
34 *Portrait of Lugné-Poe*, oil on paper glued on wood, 22.2 x 26.5 cm, 1891, Memorial Art Gallery of the University of Rochester, gift of Fletcher Steele.
35a Study for frontispiece showing Félicia Mallet in *L'Enfant prodigue* (*The Prodigal Son*), ink and watercolor on paper, 30.5 x 21 cm, 1890–91, private collection.
35b Detail from program for *La Gardienne* (*The Guardian*) at the Théâtre de l'Œuvre, lithograph, 23.5 x 30 cm, 1894, Bibliothèque Nationale de Paris.
36a *The Intruder*, oil on cardboard, 28 x 60.5 cm, location unknown.
36c Carl Koester, set for Maeterlinck's *L'Intruse* (*The Intruder*), Düsseldorf, 1906, private collection.
36b Photograph of Maurice Maeterlinck in his study at Gand, c. 1890, Fondation M. Maeterlinck, Gand.
37l Program for Henrik Ibsen's *The Master Builder* at the Théâtre de l'Œuvre, lithograph, 1894, Bibilothèque Nationale de Paris.
37r Maurice Denis, program for Henrik Ibsen's *The Lady from the Sea*, lithograph, 17 x 10 cm, 1892, private collection.
38a *The Goose*, oil on cardboard, 22 x 27 cm, 1890, private collection.
38b Ludwig Sievert, sketch for the set of Strindberg's *The Highway*, 1923, private collection.
39 *Man and Two Horses*, oil on cardboard, 26 x 34.5 cm, c. 1890, private collection.
40 Paul Sérusier, drawing for *La Fille aux mains coupées* (*The Girl with Severed Hands*) illus. from *Théâtre d'Art*, 1891–2, private collection.
40–41 *The Dinner Hour*, oil on canvas, 71.8 x 92.2 cm, c. 1890–91, Museum of Modern Art, New York, gift of Mr and Mrs Sam Salz and an anonymous donor.
41a Pierre Bonnard, *La Geste du roi* (*The King's Epic Poem*), illus. For *Le Livre d'Art*, 1891, private collection.
41b *Berthe aux grands pieds* (*Berthe with Big Feet*), oil on cardboard, 19.5 x 26.5 cm, 1891, Yasuaki Iwasaki, Kagawa, Japan.
42 Theater program, gouache, ink, and graphite on paper, 26.2 x 21 cm,
Museum of Fine Arts, Boston, gift of William Kelly Simpson.
43a *The Illusionist's Turn*, oil on cardboard, 49 x 39 cm, 1898, Fondation Bührle, Zürich.
43b Program for Ibsen's *An Enemy of the People* at the Théâtre de l'Œuvre, black and white lithograph on paper, 22 x 30 cm, 1893, private collection.
44–45 *Under the Lamp*, oil on canvas, 32.5 x 41.5 cm, Musée de l'Annonciade, Saint-Tropez, 1892.
46–47 *The Suitor*, oil on cardboard, 31.8 x 36.4 cm, 1893, Smith College Museum of Art, Northampton, Mass., Drayton Hillyer Fund, 1938. © ADAGP, Paris and DACS, London 2002.
47 *Biana Duhamel in "Miss Helyett"*, pastel on paper, 42 x 26 cm, c. 1890–92, private collection.
48 Detail of *Large Interior with Six Figures*, oil on canvas, 88 x 193 cm, 1897, Kunsthaus, Zurich.
49 Photograph of Vuillard at Villeneuve-sur-Yonne, 1899, Salomon Archives, Paris.
50 *La Causette* (*The Chat*), oil on canvas, 31.5 x 39.2 cm, c. 1892, Scottish National Gallery of Modern Art, Edinburgh.
51 *Interior, Mother and Sister of the Artist*, oil on canvas, 46.3 x 56.5 cm, c. 1893, Museum of Modern Art, New York, gift of Mrs Saidie A. May.
52l *Vallotton and Misia at Villeneuve*, oil on cardboard, 67.7 x 50.6 cm, c. 1899, William Kelly Simpson Collection.
52r Photograph by Vuillard of *Misia, Rue Saint-Florentin*, Salomon Archives, Paris.
53a *Marie Vuillard at Her*
Window, oil on cardboard, 32 x 28 cm, c. 1893, Beverly Sommer Collection, New York.
53b Page from Vuillard's *Journal*, 1890–1900. Library of the Institut de France, Paris.
54a *Woman in a Bar*, painted in tempera and gouache on paper, 20.3 x 13.9 cm, 1893–95, Cabinet des dessins, Musée du Louvre, Paris.
54b *Woman Sewing*, oil on composition board, 28 x 25.4 cm, 1893, Indianapolis Museum of Art, anonymous gift in memory of Carolyn Marmon Fesler.
55 *Woman at the Closet*, oil on paper glued on wood, 37.2 x 33.4 cm, c. 1895, Wallraf-Richartz Museum, Cologne.
56 *L'Aiguillée* or *Interior with Women Sewing* (detail and whole painting), oil on canvas, 40.3 x 32.2 cm, 1893, Yale University Art Gallery, New Haven, gift of Mr and Mrs Paul Mellon.
57a *Dressmakers*, oil on panel, 24.1 x 34.2 cm, 1893, Yale University Art Gallery, New Haven, bequest of Edith Malvina K. Wetmore.
57b *Dressmakers*, oil on canvas, 47.5 x 57.5 cm, 1890, private collection.
58 *The Striped Blouse* (whole painting and details), oil on canvas, 65.7 x 58.7 cm, 1895, National Gallery of Art, Washington, collection of Mr and Mrs Paul Mellon.
59 *Misia at the Piano and Cipa Listening*, oil on cardboard, 63.5 x 56 cm, 1897, Kunsthalle, Karlsruhe.
60–61 *Large Interior with Six Figures*, oil on canvas, 88 x 193 cm, 1897, Kunsthaus, Zurich.

Index

Photograph Credits

Art Institute of Chicago: 7, 103a. Artephot: 122. Artephot/Faillet: 44/45. Artephot/Held: 43a. Barber Institute of Fine Arts, University of Birmingham: 135. Library of the Institut de France, Paris: 16/17, 20, 21l, 21r, 53b, 73a, 113, 114, 115. Bibliothèque Nationale de France, Paris: 33, 35a, 35b, 37l. Bibliothèque Nationale de France, Paris © by SPADEM 1993: 18l. Bulloz, Paris: 68, 70/71a. J.-L. Charmet, Paris: 94, 104b. Altschul. Collection, New York: 2, 24/25. Private collection: Front cover, spine, 1, 9, 12, 13a, 18r, 26l, 28/29, 30/31a, 36a, 36c, 38b, 40, 41b, 43b, 47, 53a, 64a, 65, 97, 100/101, 109. Private collection © by SPADEM 1993: 19, 22l, 37r, 41a. Mme Simon Hodgson Collection, Paris: 106r. private collection: 3, 27, 39, 57b, 66/67. William Kelly Simpson Collection, New York: 102. D. R.: 17, 82, 83, 132. Edimedia, Paris: 63b, 108. Photo Archives Flammarion, Paris: 90/91. Fondation Bührle. Zürich: 62. Fondation M. Maeterlinck Gand: 36b. Courtesy of Galerie Bellier, Paris: 22r, 63a, 89r, 95, 103b. Galerie Bernheim-Jeune, Paris: 88a, 89l. Galerie Hopkins-Thomas, Paris: 120. Cliché Galerie (Photo Gallery) Daniel Malingue, Paris: 26br. Photo Lynton Gardiner: 111. Giraudon/Flammarion: 52l. Glasgow Museums, Edinburgh: 91a, 112. Hirshhorn Museum and Sculpture Garden, Smithsonian Institution, Washington/photo Lee Stalsworth: 64b. Fotoatelier Gerhard Howald, Bern: 92b. Indianapolis Museum of Art: 54b. Kunsthalle, Karlsruhe: 59. Kunsthaus, Zürich: 48, 60/61. Memorial Art Gallery of the University of Rochester: 34. Musée départemental de l'Oise, Beauvais/photo Tiziou: 79. Musée des Beaux-Arts de Lyon: 13b. Musée des Beaux-Arts de Nice/photo Michel de Lorenzo: 104a. Musée des Beaux-Arts de Reims/photo Devleeschauwer: 32. Musées royaux des Beaux-Arts de Belgique, Brussels: 5, 72. Museum of Fine Arts, Boston: 42, 66b. Museum of Fine Arts, Houston: 77. Museum of Modern Art, New York: 40/41, 51. National Gallery, London: 84, 86, 96b. National Gallery of Art, Washington: back cover, 6, 58, 98. Norton Simon Foundation, Pasadena: 78. UNO, Geneva, Philadelphia Museum of Art : 10. Réunion des Musées nationaux: 14a, 15l, 15r, 16, 30/31b, 54a, 69, 71c, 71b, 74/75, 76l, 76r, 99, 100, 105, 107. Réunion des Musées nationaux © by SPADEM 1993: 14b, 26ar, 87a, 87b. Rheinisches Bildarchiv, Cologne: 55. Salomon photo archives, Paris: 4, 11, 12, 22al, 22/23, 32, 35, 36a, 38a, 41cl, 49, 52r, 85, 87b, 88b, 89l, 91c, 92a, 93, 95, 96b, 101, 102, 104a, 106l, 106r, 110a, 110b, 115, 116, 117, 124, 128, 129, 130, 131, 133, 134. Scottish National Gallery of Modern Art, Edinburgh: 50, 96a. Smith College Museum of Art, Northampton: 46/47. Société immobilière du Théâtre des Champs-Elysées, Paris: 81. Société immobilière du Théâtre des Champs-Elysées, Paris/Réunion des Musées nationaux: 80a, 80b. Yale University Art Gallery, New Haven: 56, 57a, 73b.

Acknowledgments and Text Credits

The author and Editions Gallimard extend warm thanks to M et Mme Antoine Salomon; also Nadine Boucher; Claire Denis; Ann Dumas; Elisabeth Easton; Gloria Groom, Brigitte Ranson-Bitker; Antoine Terrasse; Jean-Claude, Luc and Yann Bellier; Samuel, Paul and Ellen Josefowitz and the Galerie Bernheim-Jeune. Editions Gallimard thank the publishers and rights-holders who have given permission for extracts from texts to be published: Ms. Claire Denis (pp. 116, 117, 122, 123, 126, 127); Phaidon Press Ltd. (pp. 133–4); Yale University Press (p. 134); José Corti (p. 132); Grasset (p. 127); also the *Cahiers du Musée national d'art moderne* (p. 133) and the magazine *L'Œil* (p.131).

Guy Cogeval has been director of the Montreal Museum of Fine Arts since 1998. Formerly a resident at the Académie de France in Rome, a professor at the Ecole du Louvre, and director of the Musée des monuments français from 1992 to 1996, he was the curator of the "Maurice Denis" retrospective in 1994, "Symbolism in Europe" (Montreal, 1995), "The Time of the Nabis" (Florence, 1998), and more recently "Hitchcock and Art" (2000–2001). He is the general curator of the major "Vuillard" retrospective (Washington, Montreal, Paris, London, 2003), and most notably of the painter's catalogue raisonné (to be published in 2002).

To Colette Salomon

English translation by Translate-A-Book, Oxford, England.
Editor: Gloria Groom
Typesetting: Organ Graphic, Abingdon, England

For Harry N. Abrams, Inc.
Cover designer: Brankica Kovrlija

Library of Congress Control Number: 2001097605
ISBN 0-8109-2847-7